50 Years of Recuperation
of the Situationist International

McKenzie Wark

A copublication of the Buell Center / FORuM Project
and Princeton Architectural Press

This book is copublished by

The Temple Hoyne Buell Center
for the Study of American Architecture
1172 Amsterdam Avenue
Columbia University
New York, New York 10027

Princeton Architectural Press
37 East Seventh Street
New York, New York 10003
For a free catalog of books, call 1.800.722.6657
Visit our website at www.papress.com

Library of Congress Cataloging-in-
Publication Data
Wark, McKenzie, 1961–
Fifty years of recuperation of the Situationist
International / McKenzie Wark.
 p. cm. — (FORuM project)
ISBN 978-1-56898-789-7 (hardcover : alk. paper)
1. Internationale situationniste—History. 2.
Arts, Modern—20th century. 3. Avant-garde
(Aesthetics)—History—20th century. I.
Temple Hoyne Buell Center for the Study of
American Architecture. II. Title. III. Title: 50
years of recuperation.
NX456.5.I58W37 2008
700.9'045—dc22
 2008005447

For The Temple Hoyne Buell Center

Series editor: Joan Ockman
Executive editor: Sara Goldsmith
Editorial assistant: Sharif Khalje
Copy editor: Stephanie Salomon
Designer: Dexter Sinister, New York

For Princeton Architectural Press

Production editor: Linda Lee

Special thanks to Nettie Aljian, Sara Bader,
Dorothy Ball, Nicola Bednarek, Janet Behning,
Becca Casbon, Penny (Yuen Pik) Chu,
Russell Fernandez, Pete Fitzpatrick,
Wendy Fuller, Jan Haux, Clare Jacobson,
Aileen Kwun, Nancy Eklund Later, Laurie
Manfra, Katharine Myers, Lauren Nelson
Packard, Jennifer Thompson, Arnoud
Verhaeghe, Paul Wagner, Joseph Weston,
and Deb Wood of Princeton Architectural
Press —Kevin C. Lippert, publisher

McKenzie Wark wishes to thank Eyebeam
(New York) for the honorary fellowship during
which this text was produced. A project of
the Creative Capital/Warhol Foundation Arts
Writers Grant Program.

50 Years of Recuperation of the Situationist
International is the third volume in a series of
books related to the FORuM Project, dedicated
to exploring the relationship of architectural
form to politics and urban life. FORuM is a
program of The Temple Hoyne Buell Center
for the Study of American Architecture at
Columbia University.

Project conceptualization:
Joan Ockman and Pier Vittorio Aureli
Project coordination:
Sara Goldsmith and Diana Martinez

Contents

Spectacles of Disintegration

[1,2] Who could have guessed that when the flood came it would come in slow motion, over forty decades rather than forty nights? As the polar ice sheets unravel and plunge into the waters, those who have so mismanaged the fate of all things cling to their private arks. The animals, one by one, will be saved, if at all, as gene sequences.

For those who wanted to see the preview for this blockbuster coming attraction, there was the short story of the president and the tropical storm. When the storm breached the levees and sank a fabled southern city, the president deigned to visit and show his concern, as protocol requires. Only he did not set foot there. Rather, upon leaving his vacation home, he had his personal jet detour over the sodden earth en route back to his other house. This was in order to produce the requisite photographic opportunity, of the president peering out the window with a look of compassionate conservatism, while below private armies of goons with guns secured valuable property, and the homeless were left to make a spectacle of their own misery, fans without tickets in the stadium of the endgame.

One could go on, but what's the use? Where to start; where to end? These are times when one should dispense contempt only with the greatest economy, because of the great number of things that deserve it.[1] And yet who even offers to dispense it? The newspapers are devolving, bit by bit, into shopping guides. The "quality" magazines are just coded investment advice. One turns with hope to the blogosphere, only to find that it mostly just mimics the very media to which it claims to be an *alternative*. Alternative turns out just to mean *cheaper*.

This scenario would seem like the best imaginable for a writer. What writer does not secretly want such a corrupt and venal world as *material*? In a blunted age, the scribe with one good butter knife dipped in spit has the *cutting edge*. And yet such writers hardly seem to have appeared among us. Hence the requirement of a preliminary inquiry into the causes of the decline of the quality of merciless prose.

4

At least three worlds of perception, affection, and conception must be in good working order for critical thought to touch the totality of things. These are the worlds of journalism, art, and the academy. Critical thought takes its distance from these three worlds as much as from the big world beyond them, but for that larger distance to prove useful, critical thought has to mark itself off from the closer targets of journalism, art, and the academy. In brief, these three worlds have failed to afford the conditions for their own negation.

What are we to think of American journalism? That it would be a good idea. It ceased to exist when the ruling powers discovered it more efficient, and more affordable to rule without it. This proved easier than anyone imagined. It was just a matter of turning the rigid rules of production of American journalistic prose against themselves. No story can be considered complete until its reporter has heard from both sides. So by the simple expedient of manufacturing a "side" convenient to their interests, and putting enough money behind it, the ruling powers have ensured that they will have their interests "covered" at least fifty percent of the time. All one needs is a *think tank*— so named because it is where thinkers are paid not to.

At the extreme opposite end of the cultural scale from the cheap truth of the press are the bespoke contrivances of the art world. Rather than *news you can use*, art specializes in a venerable uselessness. This uselessness bestows on art a certain autonomy from the grim dealings in shopworn slogans and infoporn that characterize all other domains of the spectacle. Or so it once seemed. If journalism finds itself recruited to the retailing of interested fables, art finds itself recruited into the prototyping of fascinating consumables. As the economy comes more and more to circulate images of things rather than the things themselves, art is detailed with the task of at last making interesting images of what these nonexistent things are not.

Meanwhile, in the academy, the talent for historical criticism has fallen into disuse. The schools no longer tolerate it. Critical theory has become hypocritical theory. If there was a wrong turn, it bears the name Louis Althusser. He legitimated a carve-up of

the realm of appearances that conformed all too neatly to the existing disciplinary arrangement. Henceforth, the economic, the political, and the ideological (or cultural) were to be treated as "relatively autonomous" domains, each with its own specialized cadre of scholars.

And thus the critical force of historical thought was separated into various specializations and absorbed back into business as usual within the spectacle. Having renounced the criticism of the world, the world—in the form of journalism, art, and the academy—can safely ignore it. The margins outside the spectacular world that once harbored a glimmer of negation have been all but foreclosed. What remains is professionalized anesthesia, mourning communities, discourse clubs, legacy fetishists. Some ages betray a deep respect for their critical thinkers. To Socrates, they offered hemlock; to Jesus, the cross. These days it's Zoloft, a column—or tenure.

The restoration of critical thought is a big project, then. Before we can take three steps forward we have to take two steps back. Back to the scene of the crime, or at least to one of them. To Paris in the 1950s, when the fateful turn toward the institutionalization of critical thought was just about to be made. Back to the last best attempt to found a critical thought in and against its institutional forms of journalism, art, and the academy.

Myths of Exemption

3–10 The Situationist International was founded by three women and six men in July 1957 in the little Ligurian town of Cosio d'Arroscia. All that remains of this fabled event are a series of stirring documents and some photographs, casual but made with an artist's eye, by founding member Ralph Rumney. He would not remain a member for long. The Situationist International dissolved itself in 1972. In its fifteen years of existence, only 72 people were ever members of it.

Its roots—so the myth goes—lie in the Paris of the early '50s, and a little group that called itself the Internationale Lettriste.

A few adventurers found each other in that lost quarter of Paris, the best-made labyrinth for retaining wanderers. There they found, in their peregrinations, the portents of the decline and fall of this world. Among this provisional micro-society were those you could define only by what they weren't. Deserters, lost children, and the girls who had run away from home and the reformatory. Professionals all—of no profession. What starts badly can, thankfully, never improve.

The modern poets led them there. They were the happy few who felt it was necessary to carry out poetry's program in reality. There could be no more poetry or art. They had to find something better. Here revolt declared itself independent of any particular cause. They engaged in a systematic questioning of all the diversions and labors of society, a total critique of its idea of happiness, expressed in acts. They were at war with the whole world, but lightheartedly. Their task was a prodigious inactivity. The only causes they supported they had to define for themselves.

The hard part was to convey through these apparently delirious proposals a sufficient degree of serious seduction. To accomplish this they resorted to an adroit use of currently popular means of communication. Their plan was to flood the market with a mass of desires whose realization is not beyond our present means but only beyond the capacity of the old social organization.

Their little group was on the margins of the economy, tending toward a role of pure consumption, and above all the free consumption of time. A few encounters were like signals emanating from a more intense life, a life not yet found. The atmosphere of a few places gave them intimations of the future powers of an architecture it would be necessary to create as the ambience for less mediocre games.

When freedom is practiced in a closed circle, it fades into a dream and becomes a mere representation of itself. Others would later promote various theories and commit assorted artistic deeds. But when one has the opportunity to take part in such an adventure as this, and has avoided all the spectacular crashes that can befall one, then one is not in an easy position.

They circled the night, consumed by fire. They had to discover how to live the days after such a fine beginning and with such a discovery: that obedience is dead.

Recuperation Perfected

Although the Situationist International achieved a certain mythic resonance in avant-garde circles, and was later identified with the events of May '68 in Paris, it did not become part of what one might call official international cultural exchange until the end of the '80s, when the Pompidou Center mounted a retrospective that toured London and Boston. This was also the year Greil Marcus published Lipstick Traces, which placed the Situationists less in art history than in the history of oppositional popular culture, which for Marcus passed through Dada and the Situationists and on to punk.[2]

Since 1987 there has been, if not a flood, then at least a steady rain of publications.[3] The effect of these has been to fix the value of the Situationists in international cultural exchange by recuperating them to one or another of the following kinds of cultural value. After 1989 it became obvious that the Situationists were part of the context for post-punk music, as the sleeve notes for the reissues rarely fail to mention.[4] (Although given that punks have turned out to be as boring as hippies, it might be time to investigate the curious collusion between Situationist practices and certain phenomena in the rave scene.) Meanwhile various attempts have been made to write them into art history.[5] The writings of the Situationists' one consistent presence, Guy Debord, now have recognized literary value.[6] His film works are now available in a boxed set.[7] The architectural legacy of the Situationists is now also extensively documented.[8] There is a consistent attempt to make the Situationists precursors to one or other species of contemporary leftism.[9] Last, they play some curious roles in contemporary philosophy.[10]

My own interest is slightly different. Rather than see the Situationists through the prism of one or another specialized branch of knowledge, I prefer to see them through the prism of

8

those groups who attempted to continue their legacy and to overcome it. I'm interested in those who, like me, read Debord's Society of the Spectacle at an impressionable age, and decided thereafter to do something with it, even if we were not sure what. These groups, active in the '80s and '90s, are not the same as the "pro-Situ" groups that could be found in the '70s, who tended to mimic Situationist slogans and practices and were prone in particular to exorbitant cataracts of dogma and boisterous bouts of mutual recrimination.[11] Interestingly, while the Situationists presented their project as beyond both art and politics, the pro-Situ groups return, not to conventional art practices, but to equally conventional politics. The groups that interest me at least attempt to reimagine the Situationist project beyond both art and politics, free to think strategically about intervening in and against other spheres.[12]

So for me the interesting things are not so much the works of scholarship about the Situationists as the attempts to plunder the treasures of this material for contemporary purposes. The Situationists created the theory and practice of *détournement*, of sampling past cultural products and integrating them into new creations, and hence the reverential quotation of Situationist texts or art is always necessarily outside of the spirit of the thing. Hence my attraction to works by the Bernadette Corporation, DJ Rabbi, DJ Spooky, Critical Art Ensemble, the Association for the Advancement of Illegal Knowledge, the Luther Blissett Project, the Neoist Alliance, and the Radical Software Group. These different outfits, in their various ways, treat the Situationist International as common property. They appropriate from it as they see fit, in precisely the manner of the "literary communism" that the Situationists themselves advocated.[13] My interest in the Situationists is in part a prolegomenon to an account of such groups. My own activities have always been closer to this approach, and have always had a difficult but fruitful relation to Situationist material.[14]

Of course, these approaches are no less acts of recuperation than any other. Recuperation began from the very moment the Situationist International was founded. It's what lends an

11

12

arresting poignancy to Rumney's photographs. On Debord's account at least, the organization was dissolved precisely because its recuperation was by 1972 already complete. By then the Situationist International had become custodian not of its own past activity but merely of its image. It had become merely a collective celebrity, part of the spectacular consumption of "radical chic." Too many elements of its work were not merely coopted but coopted *against it*. Having invaded the spectacle, the spectacle invaded it in return. It was no longer a secret enemy of spectacular society, but a known one. Its theory became ideology, mere contemplation. "Contemplation of the Situationist International is merely a supplementary alienation of alienated society."[15]

To really write, you have to read; to read, you have to live. The recuperator is unable to live. "Time scares him because it is made up of qualitative leaps, irreversible choices and once in a lifetime opportunities. The [recuperator] disguises time to himself as a mere uniform space through which he will pick his way, going from one mistake to another, one failing to the next, growing constantly richer."[16] The very least we can do now is to recuperate in an interesting way. A first step might be to recognize that the Situationists' various practices cannot be cut up within the intellectual division of labor and still make any sense. Recuperation must be all or nothing.

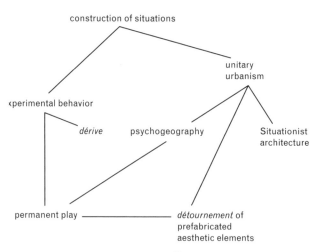

As outlined in the diagram presented on the 1957 poster 13 "New Theater of Operations for Culture," the Situationist International's concepts and practices form a unity.[17] Starting on the left, we can take the basic attitude to be *experimental behavior*. Of which only one expression is the *dérive*, or urban drift. This poses the question of what other kinds of experimental behavior one might invent. Such experiments lead to the practice of *permanent play*. This playfulness, where it concerns the raw material of existing culture, leads to the practice of *détournement*; where it concerns built environments, to *psychogeography*, or the subjective ambience of particular spaces and times. Both are reappropriation of an alienated world, subjecting it to action in the present.

Taken together, *détournement* and psychogeography imply 14 a *unitary urbanism*, of which only a component or support is a Situationist architecture. Unitary urbanism appears more as the combined product of what *détournement* can already achieve in more ephemeral media, and what psychogeography implies it could do with whole environments. Which brings us to the top of the diagram, its highest ambition, the *construction of situations*. The one thing the Situationist International never achieved was the construction of situations, although it is possible some of the alternative factions of ex-members it spawned may have come close.

To explore some of these interlocking concepts, I turn now to some interlocking biographies that pass through the official Situationist International and sometimes beyond it. Within any structure, even a largely imaginary one like the Situationist International, there is always a network. Thinking about such networks calls for a somewhat different approach to history and thought from either the biography of individuals or the history of institutions. But then reimagining what is living rather than what is dead in the Situationist archive might call for some new approaches. Howard Slater: "Historiography is one thing when it is a history in the abstract that seeks to find origins and from these origins reassume the reproduction of those already outmoded social relations."[18] But another historiography can exist, and perhaps it could in a certain sense be a Situationist one.

15 Giuseppe Gallizio (1902–64)—Pinot to his friends—was, by his own account, an "archaeologist, botanist, chemist, *parfumier*, partisan, king of the gypsies."[19] And one could add: an inventor of both performance art and the installation. It was he, together with Asger Jorn, who brought together the Congress of Free Artists in 1956 in Gallizio's hometown of Alba. This was the event that laid the groundwork for the formation of the Situationist International the following year in Cosio, where he would become a founding member. This whole coming together he described as a "chemical reaction," for which Debord's group was the catalyst.

 Gallizio's approach was consistently experimental. He saw rationalism as a kind of case-by-case justification for existing relations of power, a *casuistry*, always arguing about whether something is beautiful or ugly, good or bad, able or unable to create anything interesting. For Gallizio anything interesting would be outside the grasp of such categories. He took aim at "an elite capable of lying in order to be right all the time and not for the sake of reason." Judging legitimates power as valuation, not creation. Against which he offered "the Esperanto of color or sound or shape"—flows of sensation available to anyone.[20] For Gallizio the materials and practices of an experimental comportment are available to everyone: "the masses have understood and already the breathlessness of a new poetic moment is anxiously beating at the doors of people bored by the tired ideals fabricated by the self-righteous incomprehension of the mysterious powerful of the earth."[21]

 Gallizio's experimental practice was entirely one of process, and his interest was in the coming into being and autonomous development of aesthetic processes, which could occur by parthenogenesis. He called his work *ensemble painting*. This shifted *détournement* from the arranging of preexisting aesthetic elements to the arranging of preexisting relationships among people. His goal was what he called an *anti-patent* process for the sharing and modification of life. Painting would be like the group improvisations of jazz, or like a good cocktail,

a chemistry of combination, a symphony of emotions, made by urbanists of the minimal, creating new kinds of *civitas*.

Gallizio's ensembles did not just produce rare and singular works like other artists. They produced *industrial painting*. These were only very minimally the product of actual machines (although Gallizio did invent his own pigments and a special kiln for rapid dyeing). The idea was more that painting could be made using mechanisms of repetition and variation to undermine the unique gesture. This process of painting develops by itself, but is not predictable. Gallizio wanted to make the machine perform the unique gesture. The result would bring together the creative and singular with the serial and repeated. He invented, in short, a synthesis of the two opposed strands of the avant-garde: the Surrealists and the Constructivists. Industrial production is a quantitative concept, yet industrial painting is a form of production in which each meter of the art produced is unique. Michèle Bernstein: "a shrewd mixture of chance and mechanics."[22]

Industrial painting was an intimation of a new society of standard luxury, which could combine abundance with difference, where quantity and quality could enter into new, nondialectical relations. "Perhaps the machine is the only instrument qualified to create art that is inflationary and industrial and therefore based on the anti-patent."[23] In an unconscious echo of, and variation on, Walter Benjamin, Gallizio conjures up a mechanization of art that does not reproduce existing images but is capable of producing ever-new ones.[24] Machines, he says prophetically, "will produce so much art we won't even have the time to fix it in our memory; machines will remember for us. Other machines will intervene to destroy, determining the situations of no value; there will no longer be works of art ... but exchanges of air—ecstatic, artistic—among peoples."[25] Mirella Bandini: "unleash inflation everywhere."[26]

The potential of machines to inflate the creative production of new sensations appears on the scene as a direct result of the internal contradictions of the commodification of culture. "For all these things oh still powerful lords of the earth, sooner or later you will give us the machines to play with or we will

build them to occupy that free time that you, with crazy greed, look forward to occupying with banality and the progressive depopulation of brains."[27] The spectacle, which renders all culture equivalent, relies on an industrial base that can be turned against equivalence and exchange. Industrial painting is Gallizio's model for a generalized creative production that combines the multiplication that the machine allows with the creative processes of variation and montage.

Industrial painting implies not only a new aesthetic, but a new economy, what Gallizio called the anti-patent society. Anti-patent is a practice of exchange among creators that does not have to pass through the general equivalent of money. Rather it is an exchange based on the purely qualitative. "The currency of the future will be time-space or rather the exchange between Situationists of experience that will take place in a space-time and the scale of the phenomena will also determine the intensity."[28] One qualitative gesture calls forth another, and another, making every relationship creative, aesthetic, in a word, different. Gallizio fantasizes a society of pure difference, yet also of abundance. It is a return to the precapitalist world that he discovers in his work as an amateur archaeologist, digging up and carefully annotating the stone and pottery creations of the ancient Ligurians around his beloved Alba. But the singular creative acts of the ancients are combined in Gallizio's experimental laboratory with the overcoming of scarcity that the machine announces.

Thus emerges the non-order that at last brings social relations back in line with the non-order, or rather emergent order, of nature. The work that best embodies this is Gallizio's Cavern of Anti-Matter (produced perhaps with some painterly assistance from Soshana Afroyim). Like Jorn, Gallizio took a strong interest in contemporary science, and what his somewhat fanciful and poetic riffing on it amounts to is the intuition that late twentieth-century science was undoing the last remnants of belief in a divine and eternal order. With the death of God and the death of Art, science still played a role in legitimating bourgeois society, in providing, indirectly and often unintentionally, an image of an eternal and lawful cosmic order.

16

Gallizio anticipates the possibility of what Manuel DeLanda has called an ontology without law.[29] His <u>Cavern of Anti-Matter</u> is an all-encompassing world of pure becoming. Whereas the bourgeois appropriation of science still dreams of a law-governed cosmos that may contain islands of disorder, Gallizio proposes quite the reverse, a cosmos of chaos with islands of order: "The constants of matter will definitively collapse: all the ideologies of eternity will disintegrate in the hands of the powerful and immortality will disintegrate and the problems of eternalizing matter will increasingly fade to nothing, thus leaving the artists of chaos the infinite joy of the forever-new. The *new*, conceived with the risk of an infinite fantasy … procured from free energies that man will use in the melting down of the gold value, meant as the frozen energy from the ignoble banking system that is now decomposing."[30] All that remains is to conceive a practice of drifting through 18 a world itself adrift. Let's ride.

The *Dérive* Generalized

Your car has been stolen, that much you know. The police call to say they may have found it. They take you to see the most tangled, mangled wreck you have ever seen. The fenders are bent, the bumpers crushed, even the roof seems like someone jumped gleefully up and down on it, although it is hard to tell as the car is upside down. Gradually you piece together what happened. "Yes, this is my car," you tell the police. "I think it was stolen by incredibly drunk joyriders." It's detective work as geometry. You recognize a form that has been folded, twisted— and rotated 180 degrees.

Asger Jorn (1914–73) is widely acknowledged as one of the great mid twentieth-century artists. T. J. Clark: "the greatest painter of the fifties."[31] His contribution to the Situationists has been somewhat ignored. It is widely held that he funded it, and that even after he left it he supported Debord by donating his pictures. Yet his writings rarely show up in anthologies of Situationist material. This in spite of the fact that he made

several key contributions to the journal. The Situationist International even published a booklet of his writings on value and the economy.[32]

It doesn't help matters that Jorn's writings are next to unreadable. His prose is mercurial in a quite precise sense. It clumps together obsessively around a topic that agitates him, before speeding off like quicksilver onto something else. Still, it is possible to extract from Jorn's texts a quite unique take on the Situationist project, one he was more entitled than most to claim as in part his own.

Jorn conceives of a *situology* that would be based not just on aesthetic or political grounds, but also on geometrical ones. Situology would play out the consequences for an experimental practice built on that branch of geometry known as topology. Conventional art history sees as a decisive turning point the Euclidean geometry that enters pictorial representation as perspective in the Renaissance, but it never quite returns to advances in geometry as a source for new practices. For Jorn the situation is not just a political and aesthetic move, it is also a geometric one. The situation is a "spatial-temporal work alien to the old properties of art."[33]

One way of explaining Jorn's idea of the situation would be to say that a situation is a series of moments that are *congruent*. In classical geometry, two triangles are congruent if I can make one identical to the other by rotating, flipping, or shifting it. In topology, things are a little more complicated. In the famous example, a coffee cup and a doughnut are congruent because one can be transformed into the other by stretching, squeezing, or folding the form without making any holes in the shape. Indeed, molding doughnuts into coffee-cup shapes might be a suitably Jornian exercise.

In topology, as in classical geometry in general, time is assumed to be as uniform and even as space is. Thus, the flipping of the triangle or the squeezing of the doughnut into the coffee-cup shape can happen the same way every time. In Jorn's situology, time is not so consistent. Situology is the study of moments that are congruent with each other as a series but that are not repeatable. Situology is the experience of a situation

generalized, almost as a kind of ontology. Situology is the point of view of the joyrider of time rather than that of the detective who contemplates the stretched, squeezed, or folded remains after the event.

Jorn refutes the idea of a spatial geometry independent of time, since it is movement that creates the basis for measure and comparison, and hence for quantification and identification, in geometry. Situology studies what the Situationists elsewhere call *ambiences*, which are experienced subjectively as consistencies of mood, but which for Jorn are like blocks of time that form a temporal unity independent of the universal, abstract time that the clock measures. Situology, Jorn writes, is "that which concerns the intrinsic properties of figures without any relation to their environment."[34] Jorn wants to position avant-garde practice not only in advance of certain aesthetic, political, or cultural precedents, but in advance of mathematical ones as well. Art took over from classical geometry certain limitations. It perceives space as uniform and abstract. It conceives time as if it were a dimension of space.

Interestingly, Jorn thinks there is a countertradition in art that, in the '50s at least, was hardly well known. A conventional view might start with the Greek discovery of classical geometry, formalized by Euclid and passed on from the Hellenistic world to the Renaissance, and then on to a certain kind of modernism, exemplified by the architecture of Le Corbusier which the Situationists so reviled. Jorn counterposes to this a few instances of a different approach to geometry. If the emblematic figure for the Greek approach is the set square, Jorn's image for the countertradition is the knot, which he finds in Le Tene and other Celtic designs, for example. Half a century later we could perhaps construct a whole canon of such forms. If "situology is the transformative morphology of the unique," then we do not lack for examples of practices by which the unique was produced.[35]

The knot is not a bad emblem of a situation, at least as Jorn conceives it. Viewed from the outside, a complex knot appears as a mess of intersecting bits, like a devil's street map. But conceived intrinsically, *experienced*, as it were, it has a

consistency, despite its twists and turns. It is the "same" rope, no matter how its angle varies, or which other parts of itself it is in contact with. The knot is a situation. Learning to tie a fabulous knot is like the art of the *dérive*, in which the Situationists wandered the streets of Paris looking for consistencies of ambience, making connective threads through the street grid. The knot is Jorn's figure of situology as the *dérive* generalized. One need not wander the streets forever. The *dérive*, raised to the level of the concept, can now be practiced in almost any kind of time-space whatsoever.

If for classical geometry a triangle just "is," pure and eternal, for Jorn a knot is something that comes into being and passes out of being, is tied and untied, in time. The time that passes in the tying of the knot is part of it. A situology encompasses both the spatial and temporal aspects of form, but is still interested in the "unitary" properties of form in time. A situation is a unitary spatio-temporal figure. "The exclusion of breaks and interruptions, the constancy of intensity and the unique feeling of the propagation of the processes, which defines a situation, also excludes the division into several times...."[36] A situation is somewhere between the ordered and the random, a temporarily stable ambience or autonomy, that comes into being and passes away, as Debord would say, "in the war of time."[37] A situology is like a divining rod for discovering interesting times and spaces.

Here Jorn wants to distinguish his situology from the topology that nevertheless enables him to think it. Topology is interested in the congruence of forms, of how one form can be transformed into another by continuous deformation. Once such a congruence is proven, it can be repeated. It occurs within a universal and abstract time. Situology is not interested in the view from outside, in looking at the transformation from outside. It is more interested in the internal experience of the transformation. It is interested in blocks of space-time that are continuous and autonomous, and not necessarily repeatable.[38] Situology is topology without equivalence. "Our goal is to oppose a plastic and elementary geometry against egalitarian and Euclidean geometry, and with the help of both, to go toward a geometry of variables, a playful and differential geometry."[39]

Jorn rather boldly claims to set topology itself on the right course. "What is needed today is a thought, a philosophy, and an art that conform to that which is projected by topology, but this is only possible on condition that this branch of modern science is returned to its original course: that of the situ-analysis or situology."[40] An extravagant claim, but Jorn was writing in the climate of postwar thought, when the mainstream of mathematics, particularly in France, had taken a particularly logical, rigorous, and formalist route, and was especially suspicious of geometry. Jorn anticipates the revival of interest in complexity, chaos, and turbulence that would not come for some years.[41]

More interesting, perhaps, are the consequences Jorn intuits for more aesthetic and experimental practices. From visual art to cinema or installations or "happenings," the flat picture plane is extended into new dimensions, new spatial dimensions, the temporal dimension, but always within certain limits. "[O]ne cannot speak anymore of purely spatial phenomena," he says, "movement is there from the very beginning."[42] Art has hitherto been just like plane geometry, bracketing off the complexity of time and space, as if that complexity were an invading randomness. Jorn is pointing to a practice of the event, an aesthetics of the event, and even a politics of the event, where the event is conceived as a block of time and space that varies, deforms, morphs, but that happens in time and may not happen again. In other words, a *situation*.

Jorn draws a fateful distinction: "Here the field of situological experience is divided into two opposed tendencies, the ludic tendency and the analytic tendency."[43] On the one hand, the tendency of art and play; on the other, that of theory. The joyrider takes up the first tendency; you as the hapless car owner, the second. Jorn's ambition was for a situology that might advance both. This division is in many ways the fault line along which the Situationist International fell apart, with Debord's Paris faction pursuing the analytic tendency, and the Scandinavians around Jorn's brother Nash, the German Spur group, and Jacqueline de Jong's Situationist Times in Amsterdam pursuing the ludic. Legend has it that

gifts of artworks from Jorn helped fund all of these factions, and perhaps for him they were all fragments of a larger project whose eventual synthesis he foresaw but did not live to see. With Jorn's death in 1973 all of these incongruous Situationist projects more or less came to an end.

For Jorn, situology picked up the thread of what he imagined was something of a secret knowledge of certain morphologies. A way of tying and untying knots. The knots and other intricate patterns that decorate certain works in Jorn's countertradition are keys to a knowledge that is neither esoteric mysticism nor Platonic rationalism, but something quite different. A practical knowledge of situations. Jorn wanted to introduce time into geometry, but also chance into time.

A Galton machine is a field of equally spaced pins, above which is a slot that releases balls, and below which is a series of slots that catch them. If the top slot is positioned in the middle and balls are released into the grid, the chances are that most balls will deviate a bit when they hit the pins but will fall in one of the center slots below. A few of the balls will end up bouncing farther off the center line, but overall the device will show a Gaussian distribution.

It's essentially pinball without the fun. In pinball, the ball is always going to end up passing through the middle between the flippers, but some balls—through luck or skill—will take a long time to do so. The Galton machine, or pinball, is Jorn's image of the *dérive*. Time and space are not smooth and even. There are tilts, there are eddies, there are zones that attract the balls and zones that repel them. This is also, Jorn reminds us, how the telephone network functions. Considered in the abstract, the Galton machine or a telephone network is a flat and even field. A ball could land anywhere; a call could connect any two points. But in a richer spatial and temporal context it isn't like that. Some passages are more likely than others, but there are infinitesimal eddies and fissures shaping the ball's movement, or the call's circuit, or the swerve of someone on a *dérive*, who takes this street rather than that one. Or a joyrider who steals your car rather than mine.

For all of his theoretical extravagance, Jorn remained a painter. It would not be evident to anyone for quite some time to come just how extraordinary Jorn's practical contributions to the movement really were. In the early '60s all that was apparent was the insufficiency of painting, and the desire to abolish and transcend it. Gallizio's industrial painting might point the way, but it was still too tied to the aura of the unique and singular artwork, what Gallizio called the "oversized postage stamp." Industrial painting was still bound by what it negated and was all too easily recuperated.

The Situationists were like Nietzsche's madman in the marketplace, announcing that Art is dead, that we killed it, but that we are refusing to confront this world that is not only Godless, but Artless. Just as Man loses all coherence as a concept without the other of God, so the everyday disintegrates without the other of Art. The most extraordinary response to this challenge is surely New Babylon, a work named after a suggestion by Debord, begun while Constant Nieuwenhuys (1920–2005) was a member of the Situationist International, and continued by him for some years after his resignation.

Interestingly, of the three great Marxist utopias I know, it is the only one actually situated on earth.[44] Constant was never comfortable with the notion that his project was utopian, but then few modern utopians are. It is a form that, since it always appears as definitive, has a hard time acknowledging its predecessors, which also imagined themselves as definitive. But New Babylon is a little different in being not so much a utopia as an infrastructure for utopia. Weirdly, New Babylon is now also the name of the imaginary city of the popular evangelist Christian Left Behind book series by Tim LaHaye, about the end times of the Tribulation and the Rapture. In choosing the name New Babylon, Debord and Constant hit upon an enduring image of contested power.

Constant's ambitions were, extravagant as it may sound, more than utopian. He sought to both realize and abolish utopia. Fredric Jameson: "I believe that we can begin from

the proposition that Utopian space is an imaginary enclave within real social space, in other words, that the very possibility of Utopian space is itself a result of spatial and social differentiation. But it is an aberrant by-product, and its possibility is dependent on the momentary formation of a kind of eddy or self-contained backwater within the general differentiation process and its seemingly irreversible forward momentum."[45] In New Babylon, the chaotic eddy is not a backwater within the social order, it *is* the social order, or rather non-order. It is the smooth plane upon which random movement pushes toward emergent qualities of self-organizing form. Perhaps it makes more sense to call it not utopia (no-place) but *atopia* (placelessness).

New Babylon is a whole world at play, or at least it appears so if considered on the horizontal plane. Mark Wigley: "New Babylon is a seemingly infinite playground. Its occupants continually rearrange their sensory environment, redefining every micro-space within the sectors according to their latest desires. In a society of endless leisure, workers become players and architecture is the only game in town."[46] Considered vertically, New Babylon makes literal Marx's diagram of base and superstructure. Its sectors are literally superstructures, made possible by an infrastructure below ground where mechanical reproduction has abolished scarcity and freed all of time from necessity. It is an image of what Constant imagines the development of productive forces has made possible, but which the fetter of existing relations of production prevents from coming into being.

I want to emphasize the distinctly Marxist provenance of New Bablyon, which predates Constant's participation in the Situationist International. In the conventional historiography of the Situationist International, most are agreed that the early "artistic" phase is somehow less "radical" than the later, more "political" phase, where Debord asserts his authority over the movement and the artists, one after the other, resign or are expelled. To me it is striking how much three of the other founding figures—Gallizio, Jorn, and Constant—brought a consistent and Marxist-inflected radicalism into the movement

that is hardly detectable in the group around Debord at all in the 1950s.[47] Both the elder statesmen of the movement, Gallizio and Jorn, had minor roles, after all, in resistance movements during World War II and hardly needed confirmation from Debord in the catechism of Marx and Engels.

One can trace the Marxist strand through five texts by Constant gathered for his retrospective at The Drawing Center in 1999.[48] These texts show Constant in a consistent attempt to reimagine a politics, with and against Marx, that both pre-dates his membership in the Situationist International and continues long after he leaves it. In a 1948 "Manifesto," Constant writes critically about how "Western art, once the celebrator of emperors and popes, turned to serve the newly powerful bourgeoisie, becoming an instrument of the glorification of bourgeois ideals. Now that these ideals have become a fiction with the disappearance of their economic base, a new era is upon us, in which the whole matrix of cultural conventions loses its significance and a new freedom can be won from the most primary source of life."[49] The determinism of these sentences is on all fours with Marx's famous—and infamous—preface to his Contribution to the Critique of Political Economy: "The changes in the economic foundation lead sooner or later to the transformation of the whole immense superstructure."[50]

In 1948 Constant is thinking within the radical and experimental expressionism of the CoBrA group, of which he and Jorn were members. Whereas Debord's Lettrist group arrived at a critique of their Surrealist predecessors mostly within the logic of avant-gardist posturing, for CoBrA, Surrealism is at once a political and philosophical problem. The Surrealists imprisoned the unconscious within the logic of a Freudian analysis. They did not want to express it but to represent it. CoBrA took the other fork. Through experimental practice in which collective human agency confronts raw materials, forms and concepts can arise as products, not precepts. Since creative labor is a capacity that everyone possesses, as part of what the young Marx would call our *species-being*, experimental expression can be the basis of a people's art. An art that is as far beyond beauty and ugliness

23

as it is beyond good and evil. It is not governed in advance by aesthetic norms.

Constant will come to reject art in general, and painting in particular, and like Gallizio posit the machine as the central fact of contemporary creativity. "A free art of the future is an art that would master and use all the new conditioning techniques."[51] It offers the possibility of reconciling quality with equality. The socialist artist is no longer forced to choose between socialism and art. Constant finds the Northwest Passage out of the dreaded socialist realism or Popular Front concessions a committed artist might have had to make without landing in the territory of a rarefied and elitist vanguard art. Interestingly, it is not a question of the artist coming around to the *Realpolitik* of the party, but the party coming around to a new aesthetic reality. It is, I suggest, an intuition more powerful than Constant knew.

"The lights go out. The room is filled with a strange unintelligible noise. A huge architectural plan is projected on a wall." The camera pushes in toward the plan and discovers within its network of lines elements of a Plexiglas and steel-strut model. "The floating horizontal megastructure catches the light and stretches as far as the eye can see." The camera closes in again. "The sound of an aeroplane accompanies the descent and another set of sounds fill the room as we land on the roof deck. Each image-shift is synchronized with an acoustic shift although the sounds remain largely unintelligible."[52] In Mark Wigley's description, Constant's unveiling of New Babylon at the Stedelijk Museum in 1960 sounds like a hipster version of a new high-end condo development sales pitch. And while there are no units to invest in here, it does have some of the same logic. Constant is using multimedia to create an *ambience*, a space and time for desire. As he writes in 1963: "New Babylon is not a town planning project, but rather a way of thinking, of imagining, of looking at things and at life."[53] Constant's unitary urbanism gives concrete contours to a very real terrain, but it is that of the virtual rather than the actual. What he finds there is not the eternal formlessness of the surreal but a definite expression of historical and collective desire.

The inhabitant of this space of desire is not the banker or corporate lawyer in the market for luxury condos, but *homo ludens*, the species-being of play. The Dutch writer Johan Huizinga proposed *homo ludens* as an explicitly anti-Marxist figure, opposed to *homo faber*, the productivist worker-bee of Stalinist discourse. But as Constant discovers, what Marx always had in mind was the reconciliation of quantity and quality—the productive surplus of capitalism plus the qualitative being of the premodern world. In short, something closer to *homo ludens*: a species at play, collectively, with the materiality of its environment, under conditions of abundance that could only apply after the great productive expansion of the capitalist mode of production. As capitalism shortens the working day necessary to sustain the species, a new possibility opens up: to imagine a world in which *homo ludens*'s relation to space through play can be as free as its relation to time through leisure. *Homo ludens* will no longer make art, but will create everyday life.

New Babylon responds to both the expansion of objective resources and the expansion of population. Like a suburban family that adds a new story when the second kid is born, Constant builds a second deck for the whole planet. But rather than suburban sprawl inserting itself into any and every terrain, he imagines leaving much of the old world untouched—including, interestingly, the classic spaces of the *dérive* in the heart of the old cities such as Paris and Amsterdam. 23, 24 His is a new world that expands, not horizontally but vertically. It is "a new skin that covers the earth and multiplies its living space."[54] And why not? Who knows what built form can do?

The sectors of New Babylon are open and mobile spaces for nomadic play. There's no need to have a "home" here. By the time your wanderings bring you back to where you started it will be different anyway: "the intensity of each moment destroys the memory that normally paralyses the creative imagination."[55] Here is the architecture that Debord and his Lettriste companion Ivan Chtcheglov only dream of as they wander the streets of Paris: "Every square mile of

New Babylon's surface represents an inexhaustible field of new and unknown situations, because nothing will remain and everything is constantly changing."[56] Constant's quibbles notwithstanding, here is utopian space reimagined as a way to exit the twentieth century. Roland Barthes: "Utopia (*à la* Fourier): that of a world in which there would no longer be anything but differences, so that to be differentiated would no longer mean to be excluded."[57] Constant draws the consequence that such a space must become atopian in form and planetary in scale.

For Constant, the Situationist International "did not constitute a real movement. The adherents came and went and the only view they shared was their contempt for the current art practice."[58] He does, though, credit the movement with contemplating the end to culture conceived as scarcity and property and pursuing this possibility to its conclusions. The question of relating the impossible fragments of the movement to each other poses the problem of organization, communication, and documentation with all its pathos. Not only did the Situationist International not know how to organize the project it was bold enough to conceive, neither could it communicate its consequences. From the documentation that survives, the project remains to conceive an organizational practice. The place to start might not be with the "official" Situationist International so much as with what it excluded, among other things the so-called Second Situationist International, formed largely by the Scandinavians whom Debord expelled in the early '60s.

While the more coherent Situationist International Debord created in the '60s proved worthy of an era of heightened political tension, it could not outlive it. Thought strategically, the Situationist International shifted its sphere of operation from avant-garde art to militant politics as it moved from the late '50s to the '60s. Strategic thinking would ask what other zone of operation might be more suitable for other times. Constant's strategic interventions, in and against architecture, provide one such model. But one thing that is absent from Constant's New Babylon is a conception of how architectural space is doubled

and transformed by communicative space, both negatively, in the form of spectacle, and perhaps positively, in the form of the *détournement* of media practice that the "First" Situationist International would begin to grasp consciously as a project late in its existence.

Constant is one of the variables of the Situationist movement taken as a whole, one that it could not maintain in tension with all of its other variables. In breaking with Constant—and with Gallizio and Jorn and others—Debord would in the end be able to achieve intellectual and organizational coherence, but at the price of purging some of the tensions and differences that might have driven the movement forward. The task of recuperating the Situationist International is not to play one variable off against another—although this has been a persistent characteristic of the literature—but to discover the unknown pleasures toward which the unrecognized fragments might still direct us. In this case it is toward the paradoxical thought that Constant offered a theoretical solution to the problem of giving form to the virtual (what is real but not actual), while it was Debord who proposed an architecture for investigating the strategic potentials of escaping actual space and time. Between these two positions lies the situation.

Situationist Architecture

The only member of the Situationist International to remain in 1972 from the founding in 1957 was Guy Debord (1931–94), and he is often taken as synonymous with the movement. There are anti-Debordist accounts, which rightly stress the role of others, such as Jorn or Constant, but which often in the process privilege the earlier, more "aesthetic" phase. On this score my provocation in this essay is fourfold. First, while acknowledging the significance of Jorn, Constant, and the less well known Gallizio, I have tried to show how their work is at once both aesthetic, political, and an attempt to escape from recuperation as merely one or the other. Second, I want to insist on the centrality of a hitherto marginalized figure, Michèle Bernstein,

to whom I will return shortly. Third, I want to gesture toward the value of the work of the so-called Second Situationist International and some other excluded figures, and on this front I will discuss Jacqueline de Jong. Fourth, I want to think about Debord in a slightly different light. So I will discuss not so much his writing or his actions, but a game. Besides being a writer, a filmmaker, an editor, and a first-rate professional of no profession, he was also, of all things, a *game designer*.

Fourth things first. According to Debord's second wife, Alice Becker-Ho, Debord patented his Game of War in 1965. In 1977 he entered into a partnership with his then-publisher, Gérard Lebovici, in a company to make board games. The company published Game of War and commissioned a craftsman to make four or five sets in copper and silver. In 1987 Debord and Becker-Ho published a book about the game.[59] On this account, the game was a part of Debord's life for more than thirty years, and had its beginnings in the midst of the second, "political" phase of the Situationist International. It is, I would argue, an expression in a new form of something both the "artistic" and "political" phases of the Situationist International had in common despite their different fields of operation: namely a concept and a practice of *strategy*.

25 Debord's Game of War is a strategy game, and to see this as a major rather than minor part of his legacy is to insist that above all else Debord was a strategist. De Jong: "He was a great strategist."[60] Giorgio Agamben: "[O]nce, when I was tempted (as I still am) to consider Guy Debord a philosopher, he told me: 'I'm not a philosopher, I'm a strategist.' Debord saw his time as an incessant war, which engaged his entire life in a strategy."[59] The strategist is not the proprietor of a *field* of knowledge, but rather assesses the value of the forces aligned on any available territory. The strategist occupies, evacuates, or contests any territory at hand in pursuit of advantage.

The avant-gardes have a long-standing connection to games, and perhaps to strategy. The Surrealists invented many games.[62] Marcel Duchamp famously gave up art for chess. He even coauthored a book about it.[63] François Le Lionnais: "What [Vitali] Halberstadt and Duchamp perfected was the

theory of the relationship between squares which have no apparent connection, *les cases conjugées*, which was a sort of theory of the structure of the board. That is to say, because the pawns are in a certain relationship one can perceive invisible connections between empty squares on the board which are apparently unrelated."[64] Like the Surrealists, Debord invented his own game, but as with Duchamp, it took the form of a sustained effort to create via the game a conception of how events unfold in space.

Among the Game of War's particular qualities is that it is not a territorial game. It does not conceive of space as property, to be conquered and held. It is modeled on classic war games, which go back at least to the time of Clausewitz.[65] It includes more or less plausible parameters of movement and engagement for infantry and cavalry. Yet it is not really a game of war at all. If it is, it models something more like a full-spectrum war where the opposing sides are composed of forces not restricted by their extension only in space.

Besides the usual fighting pieces of cavalry, infantry, artillery, and the arsenal, Game of War also includes units for communication. While military units move at given speeds per turn across the board, the lines of communication, so long as they are not broken, are instantaneous and direct. This "war" can be fought as much on the plane of communication as on that of extensible space. What distinguishes the two planes is their relation to time. Debord and Becker-Ho conceive contemporary strategy as taking place in a doubled terrain, one of both spatial extension and sequential time, a space of both architecture and geography. This terrain is the other of the simultaneous time of communication—the spatio-temporal matrix that, in Society of the Spectacle (1967), Debord would come to conceive as world history.

While it looks like its eighteenth-century ancestors, Game of War is really a diagram of the strategic possibilities of spectacular time. Debord: "The bourgeoisie has thus made irreversible historical time known and has imposed it on society, but it has prevented society from using it. 'Once there was history, but not anymore,' because the class of owners of

the economy, which is inextricably tied to economic history, must repress every other irreversible use of time because it is directly threatened by them all. The ruling class, made up of specialists in the possession of things who are themselves therefore possessed by things, is forced to link its fate with the preservation of this reified history, that is, with the preservation of a new immobility within history."[66] In Game of War, history is made mobile again, in an irreversible time where strategy can reverse the course of events.

Game of War incorporates the problems of conflict in general within a manageable framework. Debord's ambition seems to be no less than to create a game which has possibilities for play that are as great as chess but which conceives of play in a different manner. That one's communication must remain intact is equivalent to the rule in chess that the king must not remain in check. Debord includes in his presentation of the game a line from the 1527 poem "Scacchia Ludus" by Marcus Hieronymus Vida (who was, incidentally, the bishop of Alba). The opening lines of the poem are: "We play an effigy of war, and battles made like / real ones, armies formed from boxwood, and play realms, / As twin kings, white and black, opposed against each other, / Struggle for praise with bicolored weapons."[67] That strategic genius, in any field, is the only thing worth commemorating is a characteristically Debordian note. Effigy is a word that might appeal to Debord in its modern sense, given how careful he was to preserve his bad reputation.[68] But here it might mean something else: that the game is a form, a mold—an allegory perhaps—for a certain kind of strategic experience.

But Game of War does not enclose space within strategy as chess does. Space is only ever partially included within the range of movement of the pieces. Some space remains "smooth" and open. The game is also subject to sudden reversals of fortune rare in chess. "In fact, I wanted to imitate poker—not the chance factor in poker, but the combat that is characteristic of it."[69] Each side makes its initial deployments in ignorance of those of the enemy, introducing at least an element of the unknown characteristic of poker.

The game requires attention to the tactical level of defending each of one's units, since once one starts losing one can quickly lose many pieces. However, units cannot move or engage unless they remain in communication with their arsenal, making lines of communication particularly vital. Players are usually more concerned with breaking the adversary's lines of communication than with offensive action directed against either the adversary's arsenal or fighting units. Outside of the quantitative struggle between blocks of fighting units is a qualitative struggle, in which a force suddenly loses all its power when the enemy cuts off its communications; "thus the outcome of a tactical engagement over just one square may have major strategic consequences."[70]

Each player has to keep three quite different aspects of the game in mind: fighting units, arsenals, lines of communication. "This war game—like war itself and like all forms of strategic thought and action—tends to demand the simultaneous consideration of contradictory requirements."[71] While attempting to maintain freedom of action, each side is also obliged to make difficult choices between qualitatively different kinds of operations, the means for the realization of which are always in short supply. One may have the means but not the time, or the time but not the means, for their realization. "Each army must strive to keep the initiative, compensating for shortfalls in troop strength by the speed with which it can concentrate its forces at a decisive point where it must be the stronger: strategic maneuvers succeed only when victory yields an immediate return, so to speak, in terms of tactical confrontation."[72]

Antonio Gramsci famously juxtaposed the concepts of the *war of position* and the *war of maneuver*. For Gramsci the war of maneuver is associated with syndicalist approaches to political conflict, with Rosa Luxemburg, and with the events of the October revolution in Russia. He associates the war of position with "mature" Leninism, and the lessons of the defeats suffered across Europe by the revolutionary movement that the October revolution was supposed to spark. Gramsci: "In the East, the state was everything, civil society was primordial and

gelatinous; in the West, there was a proper relation between state and civil society, and when the state trembled a sturdy structure of civil society was at once revealed. The state was only an outer ditch, behind which there stood a powerful system of fortresses and earthworks"[73] For Debord this line of thinking can only justify the bureaucratic apparatus of the Communist parties, their obsession with creating one institutional bunker after another, from the trade unions to the official Communist art perpetuated by former Dadaists and Surrealists such as Tristan Tzara and Louis Aragon in their waning years. Game of War is a refutation of this whole conception of strategy.

In the war of position, tactics are dictated from above by strategic concerns with taking and holding institutions across the landscape of state and civil society. The Game of War refutes this territorial conception of space and this hierarchical relation between strategy and tactics. Space is always partially unmarked; tactics can sometimes call a strategy into being. Some space need not be occupied or contested at all; every tactic involves a risk to one's positions. "It makes sense to move against the enemy's communications, but one's own will be stretched in the process."[74] As in a game of poker, advantage comes quick and is lost even quicker.

Debord moves the conception of conflict away from the privileging of space that persists in Gramsci's war of position. Key to Game of War is the question of judging the moment to move from the tactical advantage to the strategic. Tactics and strategy do not have a hierarchical and spatial relation, but a mobile and temporal one. Plans have to be changed or abandoned in the light of events. "The interaction between tactics and strategy is a continuing source of surprises and reverses—and this often right up to the last moment."[75]

Game of War is a rigorous and schematic presentation of conflict, if missing certain qualities. The spatial field is asymmetrical but unchanging. The moment of surprise comes only once, when each side reveals to the other the initial disposition of its forces. In documenting one game for their book, Debord and Becker-Ho present each move on a diagram that

outlines as a static figure the changing disposition of forces, but this gives no real sense of the ebb and tension in time of game play. Still, the ambition of Game of War is clear: "Before they went to the printers, the figures looked like a truly dazzling puzzle awaiting solution, just like the times in which we live."[76]

Whereas Jorn attempts to construct a situology of a congruent but variable unity of space and time, Debord proposes a more rigorous architectural study of how a fixed unity of space and time yields tactical and strategic advantages. Whereas Constant imagines the whole of the earth as a space for play, Debord inquires into the accumulated experience of contesting social forces that might make this other kind of play possible. War is the effigy of play. A certain kind of conflict, perhaps a new kind, has to be won before play can appear as more than a caricature of itself, screened off within its closed circle, fading into a dream.

Permanent Play

Not all is fair in war, or love. Both have their strategies, but also their rules. For example, how is a woman who lives in an "open relationship" with a man supposed to retain her hold on him if he starts an affair that has a little more intensity than affairs usually do? Affairs are allowed. They are within the rules, but they are not supposed to break with a fundamental agreement the man and woman maintain. And if this man is coming too close to breaching that agreement, what stratagems can the woman employ to see that he returns to it?

It sounds like the scenario for a French novel or movie and in a sense it is. It is that of Michèle Bernstein's two novels, Tous les chevaux du roi and La Nuit. Both cover the same events in the lives of Gilles and Geneviève but from different perspectives and in different styles. Tous les chevaux "détournes" the style of Françoise Sagan; La Nuit, that of Robbe-Grillet. Sagan's racy novels coincided with the arrival of mass paperback publishing in France in the '50s. Those

of Robbe-Grillet were a high-modernist analogue of the new consumerist and technocratic France of these years.

Both novels may be read as fictionalized accounts of the relationship between Michèle Bernstein (b. 1932) and Guy Debord, who married in 1954 and divorced in 1972, the year the Situationist International dissolved. Rather than read them for dubious historical details, it might be more interesting to take the books on their own terms, as fictions, but as presenting in fictional form a practice, perhaps even an ethics, for a Situationist conduct of everyday life. Situationist writing contains elaborate theories of fiction, but just two novels that are fictions of theory.[77]

It is fitting that Bernstein's story begins at an opening and subsequent dinner party for a mediocre Surrealist painter. As Debord wrote to Constant: "Surrealism presents itself as a total enterprise, concerning a complete way of living. It is this intention that constitutes Surrealism's most progressive character, which obliges us now to compare ourselves to it."[78] One could imagine this anecdote, from another letter in which Debord writes about an art scene party, as if it took place at the party Bernstein describes: "Madame Van de Loo, after telling me by way of a pleasantry that she was surprised to hear of practical actions involving me, whom she saw as a theoretician, was again surprised when I told her sincerely that 'nothing has ever interested me beyond a certain practice of life.' (It is precisely this that has kept me back from being an artist, in the current sense of the word, and, I hope, a theoretician of aesthetics!)"[79] Debord and, perhaps even more so, Bernstein are theoreticians who want to invent a complete way of living.

Bernstein's presentation of an ethics of life begins with the tale of the Surrealist's daughter. She says elsewhere that while Dada was the "good father" of the Situationists, the Surrealists were the "bad father."[80] Chevaux opens with a bad Surrealist father, or rather stepfather, who covets his nubile stepdaughter, Carole. In La Nuit we learn of the sexual tension between them that "though by her spite she showed that she wanted no part of it, still she encouraged it a little, admitted it was there."[81] The bad influence that matters to Gilles and Geneviève is more

aesthetic than moral, however. With a little prompting from Carole's mother, Gilles and Geneviève whisk Carole away from the old man.

Gilles takes her wandering around the streets of Paris, and in the morning finally makes love to her. In Chevaux, we only hear in general terms about Gilles and his art of wandering. Geneviève goes home to sleep and the story picks up again the next day. La Nuit is centered on the events of that night. "They pass beside a column, a streetlight rather, on which is fixed, above their heads, a blue and white sign indicating by an arrow: Cluny Museum. On the same column, another signal, luminous and blinking, is the only one that attracts the glance of the passersby. At regular intervals, for the pedestrians, the permission to pass or the order to wait flashes. Gilles and Carole pass near the column without seeing it. Gilles waits, before crossing, for the cars to stop. Carole follows Gilles, who holds her by the nape of the neck. They take the direction indicated by the sign Cluny Museum, and skirt the railings of the garden of the museum."[82] Here the famous Situationist practice of the *dérive* is Carole's initiation into the knotted streets of the sleeping city. "I'd like to be in a labyrinth with you," says Carole. "We already are," says Gilles.[83]

Gilles's affair with Carole causes at least two rifts in this libidinal universe. Carole's girlfriend Beatrice is jealous and possessive. Geneviève's feelings are perhaps more complicated. It is not the first time Gilles has had other lovers, but Geneviève is a little worried about this one. La Nuit can be read as an account of the disturbance the affair causes Geneviève. Her character is in the habit, on waking in the morning, of putting the events of the previous night in order, but in La Nuit events refuse to fall into place. The novel jumps from one fragment of time—charged with affect—to another.

Chevaux presents a rather more straightforward version of Geneviève's strategies for keeping her hold over Gilles. One strategy is to become Carole's intimate friend, establishing a relationship independent of Gilles between the two women. It is an emotional intimacy perhaps greater than the sexual one between Carole and Gilles, if rather one-sided. Carole confides

in Geneviève but not vice versa. Another strategy is to take the same liberties as her husband. Whereas Gilles found Carole at a party hosted by passé old Surrealists, Geneviève finds her love interest at the rather more advanced soirée hosted by Ole, an artist modeled perhaps on Jorn. There she hooks up with a young man called Bertrand, fucks him in a hotel, throws him out next morning, then telephones Gilles to tell him about it.

Both Carole and Bertrand make bad art. Carole dabbles at painting but she merely repeats the clichés current in the art world. Bertrand's poetry is worse, in thrall to experiments that have long since lost their charge. What neither of them quite realizes is that they already embody the aesthetic, without having to objectify it. Neither Carole nor Bertrand quite realizes that they are in play in a game of everyday life. Of the two, Carole comes closer, at least when she sings. She has a small repertoire of old French songs. For Gilles she appropriates their words as her own, détournes them, as the Situationists say. When she sings she reveals a capacity that leads Geneviève to suspect that here might be a rival.

Bertrand is handsome enough, but if anything, bringing him into the picture only gives Gilles more license to love Carole. The four of them, Gilles and Carole, Geneviève and Bertrand, go off on vacation. While on vacation, they meet Bertrand's friend Hélène, a slightly older and very sophisticated woman from the literary scene. On returning to Paris, Geneviève discards Bertrand and takes up with Hélène. This gets Gilles's attention. Gilles drops Carole. The trio of Geneviève, Hélène, and Gilles hangs out together for a while, but it doesn't last. In the end it is just Geneviève and Gilles again—for now. But the game has changed. Chevaux ends with letters from Carole and Hélène in which it is clear that Carole, while still young, is beginning to appreciate a new way of thinking about life, and that Hélène, encrusted with habit, is left to her fate.

In a letter to Bertrand, Hélène dismisses Gilles and Geneviève as "damaged people," but she does not really understand them.[84] Neither Gilles nor Geneviève are really heartless libertines. They appreciate beauty but not just as an object, a thing apart. "I wasn't built like a Greek statue,"

Geneviève remarks.[85] Their romantic strategies are not about conquest or possession. Gilles really does fall in love, and often. Geneviève's strategies are aimed at sustaining Gilles's love for her because she cannot help loving him. But this love is hardly romantic. It may be closer to the late eighteenth-century libertines in Laclos's Les Liaisons dangerouses—"Friendship joined with desire has so much the appearance of life!"—than to the early nineteenth-century romanticism of, say, Shelley's "Epipsychidion": "Love's very pain is sweet, / But its reward is in the world divine."[86] Their feelings are genuine, but feelings can be shaped aesthetically, in pursuit of adventures, in the creation of situations, in the river of time.

Love is temporal, an event. There is nothing eternal in it. Timeless love, like God, like Art, is dead. All that remains is the possibility of constructing situations. Odile Passot: "In Bernstein's universe, there is no transcendence, divine or diabolic; humans are subject to their own negativity, which they cultivate to destabilize their century's received truths."[87] Like the devils in Marcel Carné's film Les Visiteurs du soir, Geneviève and Gilles trouble the sheets of the bourgeois bedchamber by disregarding property and propriety in the name of a quite different ethic of love.[88] It's a question that is still with us, if in less exalted terms. Chris Kraus: "what kind of life could they believe in? What kind of life could they afford?"[89]

Bernstein's ethics, and politics, of love comes perhaps from the utopian socialist writings of Charles Fourier. For Fourier there are truths that we "civilized" folk are unwilling to acknowledge or to use as the basis for constructing life. Our experience of pleasure is so impoverished that it must be propped up on a wealth of illusions, above all the illusion of property rights over the affections of others. Couples demand of each other an exclusive right of emotional and sexual property—with what success, we know. Fourier: "Marriage seems to have been invented to reward perversity."[90] What will replace the incoherence of "civilized" society will be a world that has no place for bourgeois moderation or equanimity. It will call for ardent passions. Boredom and indifference are the natural

enemies of the passions. Keeping the passions in play requires a regular clash of contraries.

This Fourierist undermining of marriage as a relation of property is particularly challenging when seen in the context of the celebration of the middle-class couple as the essential unit around which postwar French consumerism and modernity was supposed to cohere. Kristin Ross: "The construction of the new French couple is not only a class necessity but a national necessity as well, linked to the state-led modernization effort. Called upon to lead France into the future, these couples are the class whose very way of life is based on the wish to make the world futureless and at that price buy security."[91]

As Geneviève says of Gilles: "When I met Gilles three years ago, I realized quickly that he was far from the cool libertine most people took him for. His desires always contain as much passion as he can put into them, and it's this same state that he always pursued in various love stories that you'd be crazy to call unserious. The climate he created everywhere is one of honest feelings and a heightened consciousness of the tragically fleeting aspect of anything to do with love. And the intensity of the adventure was always an inverse function of its duration. Trouble and breakups happened with Gilles before any valid reason appeared: afterward, it was too late. I had been the exception, I was immune."[92] Strategy, as Debord says, "tends to impose at each instant considerations of contradictory necessities."[93] Geneviève's strategies aim at the very least to maintain her immunity, but perhaps she has other ambitions as well. She might surpass her teacher at his own game.

Games turn up four times in Chevaux. Geneviève and Gilles play chess with each other. Geneviève plays a drinking game with friends and a dice game with some Americans. Gilles and Carole play "subjective" chess, where each in turn makes up the value and moves of the piece. Each move is an approximation of the more general game that for Gilles and Geneviève encompasses the whole of everyday life. This game is at times a game of skill, at times of chance. Sometimes it involves only two players, sometimes many. Sometimes the players are evenly

matched and sometimes not. Sometimes it is not clear who is playing and who is being played.

Gilles tells Carole that he and Geneviève have invented a way of staying young forever, or at least up until the end. (As Debord will say later, borrowing from Pascal, "the last act is bloody."[94]) Or as Carole writes to Gilles and Geneviève: "I dreamed of you a lot: we are walking in the forest, just before nightfall. We are holding hands in order not to lose each other. We are still children."[95]

To stay children means to keep playing the game, to keep drifting, through the streets, in and out of love. But it is a melancholy game, and Carole does not quite grasp why. As Debord says in Howls for Sade: "When freedom is practiced in a closed circle, it fades into a dream, becomes a mere representation of itself. The ambience of play is by nature unstable. At any moment 'ordinary life' can prevail once again."[96] Gilles is under no illusion about the power of love. It is not eternal. It cannot conquer time. Everything passes. And he will always leave the one he loves before the climate changes. It is how the game keeps going. It is how the young stay young.

Geneviève trumps Gilles's desire for Carole when she presents him with her affair with Hélène. While Gilles is intrigued by Carole's now lost love of Beatrice, he is much more attracted to Geneviève's for the elegant Hélène. The reconciliation between Gilles and Geneviève entails not so much a renunciation of their desire for others, but rather a gift of the renunciation of that desire to each other. But while this ending has the appearance of equity, it is really Geneviève who wins the game. She secures her alliance with Gilles, sees off her rival, and does it without invoking proprietary rights. She does not insist that Gilles be "hers," or that she is "his."

The title Tous les chevaux du roi does not refer as it might in English to "all the king's horses" of "Humpty Dumpty," but to an old song, "Aux marches du palais." Carole sings it on the night when she and Gilles and Geneviève fall into each others' lives. It is a song about a queen and her lover. One night he steals into the king's castle and lies with the queen in her bed. Together they make a river that all the king's horses cannot

cross. Greil Marcus: "It is as deep and singular an image of revolution as there has ever been, but in <u>Tous les chevaux du roi</u> so distant an element it is barely an image at all."[97] When one is bored with the desire for mere things, there is only the desire for another's desire. Gilles desires Geneviève's desire for Hélène. But what if one could create a desire so strong that it put a river between it and its other? A desire that, like a river, has to keep moving, has always to change, a desire that can play out in time and play in the end into the sea.

The *Détournement* of *Détournement*

28–30 Jacqueline de Jong (b. 1939) was a member of the Situationist International for only a brief period. She was Jorn's lover and had made the pilgrimage to Alba to work with Gallizio. When she left in protest over the way the artists of the German Spur group had been expelled in an atmosphere of mutual recriminations, she was a member of the central committee. In a handwritten note about these events she wrote, perhaps addressing Debord: "I'm proud you call us gangsters, nevertheless you are wrong. We are worse: we are Situationists."[98] She goes on to articulate, for the first time, an accurate formula for the impasse into which the Situationists had wandered: "The Situationist International has to be considered either as an avant-garde school which has already produced a series of first-class artists thrown out after having passed through their education OR as an anti-organization based upon new ideology which is situationist and which has not yet found in details its clear formulations in the fields of science, technique, and art."[99]

 This anti-organization could perhaps not quite appear yet, but she was right in proposing that the Situationist International had functioned as a school for scandal, through which many fabulous (one would not say distinguished) writers and artists passed. She added the first principle of the new anti-organization to come: "Everybody who develops theoretically or practically this new unity is automatically a member of

the situationist international and in this perspective The Situationist Times."[100]

This principle would be taken up by the largely Scandinavian Second Situationist International, whose founding document de Jong signed: "now everyone is free to become a Situationist without the need for special formalities." This text was rather philosophical about the split between what it saw as the French and Scandinavian approaches. Debord's practice it identified as that of *position*, in opposition to the Scandinavians'—one is tempted to say Jorn's—of *mobility*. "In the argument neither side can claim to have a monopoly on the right ideas."[101] The distinction does not seem quite right. Perhaps it is rather one between an analytic conception of mobility in a fixed space and a ludic conception of mobility in an open and variable space.

The Second International hung together for a decade or so, producing extraordinary work and one or two interesting situations.[102] They took the practice of art directly into everyday life to create situations as experiments in ways of behaving and being together. Their sophistication was at the level of participatory experiments. Nothing in their writing stands comparison to what T. J. Clark once called the "chiliastic serenity" of Debord's key texts.[103] But what was perhaps lost in the breakup of the Situationist International was the opportunity to combine Debord's strategy with Jorn's situology in an expanded terrain that includes Bernstein's aesthetics of love, all of which would require an anti-patent collaboration that could delimit the surfaces of the space of its own ongoing possibility, which might look something like New Babylon. Keeping the passions in play takes a periodic clash of contraries.

The Situationist Times, which de Jong edited from 1962 to 1967, is a remarkable set of documents. The early issues were edited jointly with Noël Arnaud (1919–2003), who was a hospital administrator by profession, a member of Dada and Surrealist groups, of CoBrA and Oulipo, and a Satrap of the College of Pataphysics. He was, in short, a walking history of the avant-gardes and the sort of person Debord avoided, at least in public, like the plague. Recruiting him perhaps suggests de Jong's awareness that the Situationists' recuperation of their own

31

immediate avant-garde past was by no means complete.

The Situationist Times was initially proposed by de Jong in 1961 while she was still a member of the Situationist International. She recognized the need for an English-language journal of the movement. Perhaps she realized that it was no longer possible for a transnational avant-garde to use French as its *lingua franca*. She was the person often caught translating between the French speakers and the German section. At the infamous presentation of the Situationist International at the Institute for Contemporary Art in London in 1960, she was even called on to vet a translation of the key speech that Ralph Rumney had made from French to English—a language Rumney suspects she barely spoke at the time.

The Situationist Times, produced outside of the Situationist International itself, turned out to be a somewhat different beast. It was often multilingual rather than English-language, and even as such more written in what I have elsewhere called "Englishes"—English unapologetically written as a second language patterned after the writer's first language.[104] It anticipates the Englishes that flourished in the transnational post-cyberpunk underground documented and coordinated by Nettime.[105]

The Situationist Times pursued something of a middle course between the experimental practice of the Scandinavians and the strategic logics of the Franco-Belgian group, who remained the core of the original Situationist International. De Jong was interested in a logic of images, of concepts that might be discovered and presented through the proliferation of images. The Situationist Times operates in something like Gallizio's realm of industrial painting, where new relationships and possibilities might be discovered in the plentitude of the image, but where the medium is print, not paint.

The first issue defended the Spur group, expelled from the Situationist International at a time when charges were being brought against them for their "licentious" publication. It also presented what remained of Mutant, a post-Situationist International collaboration between Jorn and Debord that aimed to turn away from the then current spectacle of the

"space age" toward a prescient intervention in the technological transformation of earthbound life. It also introduced material for an ongoing investigation of topology, in keeping with one of Jorn's key interests. The third and fourth issues expanded on the figure of the knot and topology in general, and extensively documented Jorn's pet theory that there existed in Europe 32 an alternative geometrical culture, one able to think spatial extension and temporal process together.

Each issue contained the statement, consistent with this topological thought and with established Situationist practice, to the effect that "all reproduction, deformation, modification, derivation, and transformation of the The Situationist Times are permitted." This was similar to the "copyleft" statement published in Internationale Situationniste, and connects Situationist practice with the hacker and pirate practices of present-day struggles around free culture as a fitfully acknowledged if still barely understood precursor.

The Second Situationist International set itself up as both a rival and a replacement for the Situationist International. Its principals had in mind the relationship between the Workingmen's Association of which Marx was a somewhat cantankerous member and the more Social Democratic Second International that succeeded it. Less doctrinaire and inflexible than Debord's group, it was in some ways less interesting for conceiving of a relation to Situationist thought and practice today than de Jong's The Situationist Times. De Jong's actions amounted less to a split within the movement than a *détournement* of it. No longer a secret enemy of spectacular society but a known one, Situationist thought and practice had to change. As to how it might change and what it might become, this is work that was barely begun in The Situationist Times. Perhaps the problem is not the recuperation of "situationism" in the fifty years since the inception of the Situationist International, but that the recuperation is so partial and incomplete. After all of the variables of the movement are accounted for, they might lend themselves again to an agency that is at once critical and creative.

At least some of the key elements are here before us. Experimental behavior, for instance. The word *experimental* has lost all precision. But it can be understood, with Gallizio, as anti-patent exchanges of creative experience, forming ensembles that produce works both in abundance and infinitely differentiated. The practice of *dérive* is more than just an urban walkabout. As Jorn proposes, it is a practice connected to the discovery of the *qualities* of any block of space and time. Constant points toward a realist concept of built space in negative. His is the best example of what modern capitalism has refused us. Debord, far from being a messianic figure, emerges as the conceptual architect of acting strategically in given blocks of space and time. Bernstein shows how the spaces and times available for experimental comportment traverse the public/private divide, and that it doesn't take a *multitude* to conceive of a new sovereign practice of permanent play. She also shows that play contains, rather than escapes, the problem of power. De Jong shows us that all of this material is already available to us to détourne in the interest of new experiments, new conceptions.

33 The Situationists are nobody's property. They belong now to the very "literary communism" that Debord and company announced before the movement had even really begun. But before we can proceed to a new practice and escape their orbit, the Situationists present us with some unfinished business. The *dérive* has to become a practice within the archive, allowing the discovery of the hidden ambiences within the Situationist stacks that escape the division of intellectual labor. The elements thus freed have to be recuperated fully rather than partially. Which, last, might raise *détournement* to a new level, to a sovereign appropriation of appropriation itself. If journalism, art, and scholarship fail us as the resources for critical leverage, the archive yields their shadow image, revealing in outline the cultural resources we do not have, but require, for leaving the twenty-first century.

Notes

1. After Chateaubriand, as quoted in Guy Debord, "Refutation of All Judgments," in Guy Debord: Complete Cinematic Works, trans. Ken Knabb (Oakland, CA: AK Press, 2003), p. 111. The reader is hereby notified that many of the best lines in the present essay have been lifted from other sources without acknowledgment.

2. Elizabeth Sussman, ed., On the Passage of a Few People through a Rather Brief Moment in Time: The Situationist International 1957–1972 (Cambridge, MA: MIT Press, 1989); and Greil Marcus, Lipstick Traces: A Secret History of the Twentieth Century (Cambridge, MA: Harvard University Press, 1989).

3. Simon Ford, in The Realization and Suppression of the Situationist International: An Annotated Bibliography 1972–1992 (Stirling, UK: AK Press, 1995), documents mostly the English-language reception from the pro-Situ milieus of the 1970s to the first "boom" in interest around 1989.

4. A reading vigorously disputed in Stewart Home, The Assault on Culture: Utopian Currents from Lettrisme to Class War (Stirling, UK: AK Press, 1991); and Stewart Home, Cranked Up Really High: Genre Theory and Punk Rock (Hove, UK: Codex, 1995).

5. See Tom McDonough, ed., Guy Debord and the Situationist International: Texts and Documents (Cambridge, MA: MIT Press, 2002); and Tom McDonough, The Beautiful Language of My Century: Reinventing the Language of Contestation in Postwar France 1945–1968 (Cambridge, MA: MIT Press, 2007).

6. See Vincent Kaufman, Guy Debord: Revolution in the Service of Poetry, trans. Robert Bonono (Minneapolis: University of Minnesota Press, 2006); and Martin Puchner, Poetry of the Revolution: Marx, Manifestos, and the Avant-Gardes (Princeton: Princeton University Press, 2006).

7. Guy Debord, Oeuvres cinématographiques complètes (Gaumont Video, 2005).

8. See Libero Andreotti and Xavier Costa, eds., Theory of the Dérive and Other Situationist Writings on the City (Barcelona: Actar, 1996); Simon Sadler, The Situationist City (Cambridge, MA: MIT Press, 1999); and Alberto Iacovoni, Game Zone: Playgrounds between Virtual Scenarios and Reality (Basel: Birkhäuser, 2004); Francesco Careri, Walkscapes (Barcelona: Editorial Gustavo Gili, 2003).

9. For example, Anselm Jappe, Guy Debord (Berkeley: University of California Press, 1993); Darrow Schecter, History of the Left from Marx to the Present (London: Continuum, 2007); and Gerald Raunig, Art and Revolution: Transversal Activism in the Long Twentieth Century (New York: Semiotext(e), 2007).

10. See Sadie Plant, The Most Radical Gesture: The Situationist International in a Postmodern Age (London: Routledge, 1992); or more recently, John Roberts, Philosophizing the Everyday: Revolutionary Praxis and the Fate of Cultural Theory (London: Pluto Press, 2006). Guy Debord has interesting walk-on parts in Alain Badiou, The Century, translated by Alberto Toscano (Cambridge: Polity, 2007); and Simon Critchley, Infinitely Demanding: Ethics of Commitment and the Politics of Resistance (London: Verso, 2007). It would be worth investigating his "structural" role in these last two cases.

11. Of particular interest are a number of British publications such as Here and Now, Smile, Vague, Break/Flow, and pamphlets from the London Psychogeographical Association. On the history of British pro-Situs, see King Mob Echo 7 (2000); and Stewart Home, ed., What Was Situationism? A Reader (Edinburgh: AK Press, 1995).

12. For example, Adilkno, Media Archive (New York: Autonomedia, 1998); Critical Art Ensemble, Digital Resistance: Explorations in Tactical Media (New York: Autonomedia, 2001); Stewart Home, Neoism, Plagiarism and Praxis (Edinburgh: AK Press, 1995); Josephine Bosma et al., eds., Readme! Filtered by Nettime ASCII Culture and the Revenge of Knowledge (New York: Autonomedia, 1999). The introduction to the latter begins: "Nothing is spectacular if you are not part of it."

13. See Guy Debord and Gil Wolman, "Methods of Détournement," in Ken Knabb, ed., Situationist International Anthology (Berkeley, CA: Bureau of Public Secrets, 1985), p. 11.

14. Four of my books can be read as a reworking of some core concepts: Virtual Geography (Bloomington: Indiana University Press, 1994), of Debord's theory of time; Dispositions (Cambridge: Salt Publishing, 1999), of the dérive, or drift, in the age of global positioning satellites; A Hacker Manifesto (Cambridge, MA: Harvard University Press, 2004), of digital détournement, or appropriation; and Gamer Theory (Cambridge, MA: Harvard University Press, 2007), of play in the age of compulsory creativity. The present essay is thus a "settling of accounts."

15. Guy Debord and Gianfranco Sanguinetti, The Real Split in the International, translated by John McHale (London: Pluto Press, 2003), p. 33.

16. Ibid., p. 37.

17. Gérard Berreby, ed., Textes et documents Situationnistes 1957–1960 (Paris: Editions Allia, 2004), p. 47.

18. Howard Slater, "Divided We Stand: An Outline of Scandinavian Situationism," Infopool 4 (2001).

19. Giorgina Bertolino et al., eds., Pinot Gallizio: Il laboratorio della scrittura (Milan: Charta, 2005), p. 20.
20. Quoted in ibid., p. 135
21. Quoted in ibid., p. 164.
22. Michèle Bernstein, "In Praise of Pinot Gallizio," in McDonough, ed., Guy Debord and the Situationist International, p. 70.
23. Quoted in Bertolino, Pinot Gallizio: Il laboratorio della scrittura, p. 171.
24. See Walter Benjamin, "The Work of Art in the Era of Mechanical Reproducibility: Second Version," Selected Writings, vol. 3, 1935–38 (Cambridge, MA: Harvard University Press, 2002), pp. 101–33.
25. Bertolino, Pinot Gallizio: Il laboratorio della scrittura, p. 172.
26. Mirella Bandini, "An Enormous and Unknown Chemical Reaction," in Sussman, On the Passage of a Few People through a Rather Brief Moment in Time, p. 72.
27. Bertolino, Pinot Gallizio: Il laboratorio della scrittura, p. 172.
28. Ibid., p. 27.
29. Manuel DeLanda, Intensive Science and Virtual Philosophy (London: Continuum, 2002), p. 4.
30. Ibid., p. 171.
31. T. J. Clark, Farewell to an Idea (New Haven: Yale University Press, 2001), p. 389.
32. Reprinted in Asger Jorn, The Natural Order and Other Texts, trans. Peter Shield (Aldershot, UK: Ashgate, 2002), p. 121ff.
33. Asger Jorn, "La Création ouverte et ses ennemis," Internationale Situationniste 5 (December 1960), pp. 29–50. English translations here and following are by the author unless otherwise attributed.
34. Ibid., p. 39.
35. Ibid., p. 40.
36. Ibid., p. 39.
37. Guy Debord, "In girum," in Guy Debord: Complete Cinematic Works, p. 150.
38. Asger Jorn, "La Pataphysique, une religion en formation," Internationale Situationniste 6 (August 1961), pp. 29–32.
39. Asger Jorn, "La Création ouverte et ses ennemis," p. 42.
40. Ibid., p. 44.
41. James Gleick, Chaos: Making a New Science (Harmondsworth, UK: Penguin, 1988).
42. Asger Jorn, "La Création ouverte et ses ennemis," p. 44.
43. Ibid., p. 45.
44. Both A. A. Bogdanov and Kim Stanley Robinson built their utopias on Mars. A. A. Bogdanov, Red Star: The First Bolshevik Utopia (Bloomington: Indiana University Press, 2006); and Kim Stanley Robinson, Red Mars (New York: Harper Collins, 1992). Despite the title, Bogdanov broke with Lenin, and in a sense his Red Star is not "Bolshevik" at all. If one reason to read the Situationists is as a counterweight to the quite strange Leninist revival perpetrated by Slavoj Zizek and Alain Badiou, Bogdanov too might be due for an untimely "rehabilitation."
45. Fredric Jameson, Archaelogies of the Future (London: Verso, 2005), p. 15.
46. Mark Wigley, ed., Another City for Another Life: Constant's New Babylon, Drawing Papers 3 (New York: The Drawing Center, 1999), p. 9.
47. On Jorn's working-through of his Marxist and syndicalist inheritance, see Graham Birtwhistle, Living Art: Asger Jorn's Comprehensive Theory of Art (Utrecht: Reflex, 1986). Constant's fastidious relation to the letter of Marx comes out in the interview with him in Catherine de Zegher and Mark Wigley, eds., The Activist Drawing (Cambridge, MA: MIT Press, 2001).
48. The Decomposition of the Artist: Five Texts by Constant, addendum to Wigley, Another City for Another Life: Constant's New Babylon.
49. Constant, "Manifesto" (1948), The Decomposition of the Artist, p. a2.
50. Karl Marx, "Preface" to A Contribution to the Critique of Political Economy, in Early Writings, trans. Rodney Livingstone (Harmondsworth: Penguin, 1975), p. 426. The relation of the CoBrA artists to Marx is complicated. Jorn argued at the time that art was not infrastructural, but superstructural. It was for him the qualitative aspect of social labor.
51. Constant, "On Our Means and Our Perspectives" (1958), The Decomposition of the Artist, p. a7.
52. Mark Wigley, "The Great Urbanism Game," Architectural Design, special issue on New Babylonians, ed. Iain Borden and Sandy McCreery, vol. 71, no. 3 (June 2001), p. 9.
53. Constant, "Lecture Given at the ICA, London" (1963), The Decomposition of the Artist, p. a9.
54. Ibid., p. a12.
55. Ibid., p. a13.
56. Ibid.
57. Roland Barthes, Roland Barthes by Roland Barthes (New York: Noonday Press, 1989), p. 85.
58. Constant, "The Rise and Decline of the Avant-Garde" (1964), The Decomposition of the Artist, p. a26.
59. Alice Becker-Ho, "Historical Note (2006)," in Alice Becker-Ho and Guy Debord, A Game of War, translated by Donald Nicholson-Smith (London: Atlas Press, 2007), p. 7.
60. Jacqueline de Jong, in Stefan Zweifel et al., eds., In Girum Imus Nocte et Consumimur Igni: The Situationist International 1957–1972 (Zurich: JRP-Ringier, 2006), p. 240.

61. Giorgio Agamben, in ibid., p. 36.
62. See Susan Laxton, Paris as Gameboard: Ludic Strategies in Surrealism (Ph.D. diss., Columbia University, 2004).
63. Marcel Duchamp and Vitali Halberstadt, L'Opposition et les cases conjuguées sont reconciliées/Opposition und Schesterfelder sind durch versohnt/Opposition and Sister Squares Are Reconciled (Paris: L'Editions l'Echiquier, 1932).
64. Quoted in Allan Woods, The Map Is Not the Territory (Manchester, UK: Manchester University Press, 2000), p. 199.
65. See Ed Halter, From Sun Tzu to Xbox (New York: Thunder Mouth Press, 2006).
66. Guy Debord, Society of the Spectacle, trans. Ken Knabb (London: Rebel Press, 2005), para. 143.
67. Thanks to Michael Pettinger for this translation.
68. See Guy Debord, Cette mauvaise réputation (Paris: Gallimard, 1993).
69. Becker-Ho and Debord, A Game of War, p. 156.
70. Ibid., p. 19.
71. Ibid., p. 21.
72. Ibid.
73. Antonio Gramsci, Selections from The Prison Notebooks, trans. Quintin Hoare and Geoffrey Nowell Smith (New York: International Publishers, 1971), p. 238.
74. Becker-Ho and Debord, A Game of War, p. 22.
75. Ibid., p. 24.
76. Guy Debord, "Preface to the First Edition," in ibid., p. 9.
77. More could be said about a Situationist approach to the novel and about novels that were key to the movement, such as those by Malcolm Lowry and Louis-Ferdinand Céline, or those it inspired, such as Patrick Straram's recently rediscovered Les Bouteilles se couchent (Paris: Editions Allia, 2006), or Georges Perec's Things: A Story of the Sixties (Boston: David R. Godine, 1990), or Philippe Sollers's The Park (New York: Red Dust, 1977).
78. Debord to Constant, 8 August 1958, in Guy Debord, Correspondance, vol. 1 (Paris: Fayard, 1999). Thanks to Bill Brown for this reference.
79. Debord to Constant, 26 April 1959, in ibid.
80. Zweifel, In Girum Imus Nocte et Consumimur Igni: The Situationist International 1957–1972, p. 9.
81. Michèle Bernstein, La Nuit (Paris: Buchet-Chastel, 1961), p. 40.
82. Ibid., p. 18.
83. Ibid., p. 92.
84. Michèle Bernstein, Tous les chevaux du roi (Paris: Editions Allia, 2004), p. 116. I would like to thank John Kelsey for making his translation of this text available to me. I have modified his translation slightly here and there.
85. Ibid., p. 53.
86. Choderlos de Laclos, Les Liaisons dangereuses, translated by P. W. K. Stone (London: Penguin, 1961), p. 364; Percy Bysshe Shelley, "Epipsychidion," in The Poetical Works of Shelley, ed. Newell F. Ford (Boston: Houghton Mifflin, 1974), p. 306.
87. Odile Passot, "Portrait of Guy Debord as a Young Libertine," Substance 3 (1999), p. 77. Odile Passot is a pseudonym; this text was actually written by Jean-Marie Apostolidès. See his Les Tombeaux de Guy Debord (Paris: Flammarion, 2006).
88. See Marcel Carné, Les Visiteurs du soir, 1942, with screenplay by Jacques Prévert and Pierre Laroche.
89. Chris Kraus, I Love Dick (New York: Semiotext(e), 1997), p. 97.
90. Charles Fourier, The Theory of the Four Movements (Cambridge: Cambridge University Press, 1996), p. 111.
91. Kristin Ross, Fast Cars, Clean Bodies (Cambridge, MA: MIT Press, 1995), p. 148. For the characters in Bernstein's novels, it's more like fast bodies, clean cars.
92. Bernstein, Tous les chevaux du roi, p. 36.
93. Len Bracken, Guy Debord Revolutionary (Venice, CA: Feral House, 1997), p. 245.
94. Guy Debord, Panegyric, Books One and Two, translated by James Brook and John McHale (London: Verso, 2004), p. 61.
95. Bernstein, Tous les chevaux du roi, p. 113.
96. "Howls for Sade," Guy Debord: Complete Cinematic Works, p. 17.
97. Greil Marcus, Lipstick Traces, p. 423.
98. Jacqueline de Jong, "Critic on the Political Practice of Détournement," The Situationist Times 1 (1962).
99. Ibid.
100. Ibid.
101. "The Struggle for the Situcratic Society," signed by Nash, de Jong, et al., The Situationist Times 2 (1962).
102. See Howard Slater, "Divided We Stand: An Outline of Scandinavian Situationism."
103. T. J. Clark, The Painting of Modern Life (Princeton, NJ: Princeton University Press, 1984), p. 10.
104. See Emily Apter, The Translation Zone: A New Comparative Literature (Princeton, NJ: Princeton University Press, 2005), p. 226ff.
105. See Josephine Bosma et al., eds., Readme!.

47

1 Chris Jordan, Cell phones #2, Atlanta, 2005. From
the series Intolerable Beauty: Portraits of American
Mass Consumption. Courtesy Chris Jordan
2 Edward Burtynsky, Manufacturing #16, Ningbo,
Zheijang Province, 2005. From the series China.
Courtesy Edward Burtynsky and Charles Cowles
Gallery, New York/Robert Koch Gallery, San
Francisco/Nicholas Metivier Gallery, Toronto
3–10 Ralph Rumney, photographs taken in Cosio
d'Arroscia, Italy, July 1957. Courtesy Avery
Architectural and Fine Arts Library, Columbia
University
11 Film still from Bernadette Corporation, Get Rid
of Yourself, 2003. Courtesy Bernadette Corporation
12 Game still from Radical Software Group,
Kriegspiel: Guy Debord's 1978 "Game of War," 2008.
Courtesy Radical Software Group
15 Pinot (Giuseppe) Gallizio and gypsies, Alba,
Italy. Photographer unknown. Courtesy Archivo
Gallizio, Turin
16 Pinot (Giuseppe) Gallizio and Soshana Afroyim,
in Cavern of Anti-Matter installation, René Drouin
Gallery, Paris, 1959. Photographer unknown.
Courtesy Archivo Gallizio, Turin
17 Pinot (Giuseppe) Gallizio, Cavern of Anti-Matter,
Installation view, René Drouin Gallery, Paris,
1959. Photographer unknown. Courtesy Archivo
Gallizio, Turin
18 Pinot (Giuseppe) Gallizio, Untitled (detail),
1959. Photographer unknown. Courtesy Archivo
Gallizio, Turin
21 Constant, New Babylon Yellow Sector, 1958–61.
Courtesy Victor Nieuwenhuys
22 Constant, Combination of Sectors, 1958–61.
Courtesy Victor Nieuwenhuys
23 Constant, New Babylon Paris, 1963. Collection of
the Gemeentemuseum, The Hague
24 Constant, New Babylon Amsterdam, 1963.
Collection of the Gemeentemuseum, The Hague
28 Jacqueline de Jong with Pinot (Giuseppe)
Gallizio in Alba, Italy, 1960. Photographer unknown.
Courtesy Jacqueline de Jong
29 Jacqueline de Jong with Asger Jorn at an
opening of an exhibition of collages by Jacques
Prévert, 1962. Photographer unknown. Courtesy
Jacqueline de Jong
30 Jacqueline de Jong in her Paris studio.
Photographer unknown. Courtesy Jacqueline
de Jong
33 Kevin C. Pyle and McKenzie Wark, Cataract
of Time, 2007. From Totality for Kids, on-line
work in progress

1 Chris Jordan, Cell phones #2, Atlanta, 2005.
From the series Intolerable Beauty: Portraits of Mass American Consumption

2 Edward Burtynsky, Manufacturing #16, Ningbo, Zheijang Province, China, 2005.
From the series China

With the development of capitalism, irreversible time is unified on
a world scale.... What appears the world over as the same day is
the time of economic production cut up into equal abstract fragments.
Unified irreversible time is the time of the world market and, as a
corollary, of the world spectacle. —Guy Debord

3–8 Ralph Rumney, photographs taken in Cosio d'Arroscia, July 1957.
Identifiable are Michèle Bernstein, Guy Debord, Piero Sismondo, and Elena Verrone.

I got summoned, or invited, to Cosio d'Arroscia. So we went there and Debord turned up with this tract he'd written and we founded the Situationist International. Sismondo had a place there. He was a friend of Jorn's and Jorn was living nearby ... anyway Piero had this place, or his aunt had a hotel there where we could all stay and get free food. So we stayed there for a week getting drunk, and that was how the Situationist International was formed. —Ralph Rumney

9 Ralph Rumney, photograph taken in Cosio d'Arroscia, July 1957. Portrait of Michèle Bernstein

10 Ralph Rumney, photograph taken in Cosio d'Arroscia, July 1957. Portrait of Guy Debord

Since each particular feeling is only a part of life and not life in its entirety, life yearns to spread into the full diversity of feelings so as to rediscover itself in the whole of this diversity ... In love, the separate still exists, but it exists as unified, no longer as separate: the living meets the living. —Guy Debord

11 Bernadette Corporation, film still from Get Rid of Yourself, 2003

12 Radical Software Group, game still from <u>Kriegspiel: Guy Debord's 1978 "Game of War"</u>, 2008

What we need to begin thinking about is the totality of society under attack. We are facing a new subjective space, one that threatens power and ignores it. It's not political because it refuses any social role. There are no demands, there are no negotiations. It's a mass exodus on the spot. —Bernadette Corporation

NOUVEAU THÉATRE D'OPÉRATIONS
DANS LA CULTURE

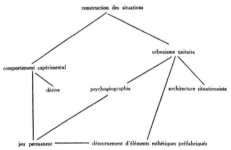

LA DISSOLUTION DES IDEES ANCIENNES VA DE PAIR AVEC LA DISSOLUTION DES ANCIENNES CONDITIONS D'EXISTENCE :

INTERNATIONALE
SITUATIONNISTE

édité par la section française de l'I.S. — 32, rue de la montagne-geneviève, paris 5ᵉ

13 Poster for the Internationale Situationniste, 1958

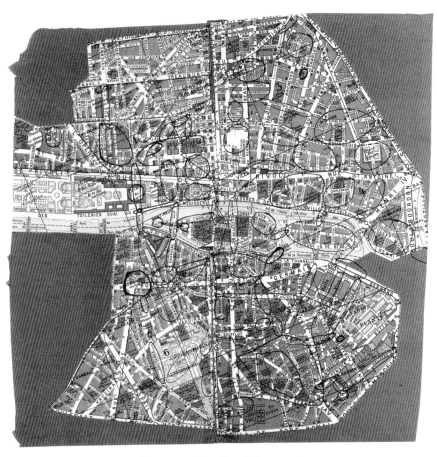

14 Guy Debord, Map of Paris before 1957, 1957

I know Gilles's thing for walking all night, how a café still open late becomes a precious port of call in streets where somnambulists normally don't go. After two, rue Mouffetard is deserted. You have to go up to the Pantheon to find a bar, to rue Cujas. The next stop is by the Senate, then rue du Bac, if you really want to steer clear of what we still call the Quartier. Here, I guess Carole told him the story of her life (if she even had one yet). And then the sun starts to rise over Les Halles—it's a ritual. —Michèle Bernstein

15 Pinot (Giuseppe) Gallizio and gypsies, Alba, Italy. Photographer unknown

16 Pinot (Giuseppe) Gallizio and Soshana Afroyim in Cavern of Anti-Matter installation, René Drouin Gallery, Paris, 1959. Photographer unknown

The gypsies rightly contend that one is never compelled to speak the truth except in one's own language; in the enemy's language, the lie must reign. —Guy Debord

17 Pinot (Giuseppe) Gallizio, Cavern of Anti-Matter, installation view,
René Drouin Gallery, Paris, 1959. Photographer unknown

18 Pinot (Giuseppe) Gallizio, <u>Untitled</u> (detail), 1959

The patented society, conceived and based on simple ideas, on the
elementary gestures of artists and scientists reduced to captivity
like fleas by ants, is about to end; man is expressing a collective sense
and a suitable instrument for transmitting it in a potlatch system of
gifts that can only be paid for by other poetic experiences.
—Pinot (Giuseppe) Gallizio

19 Laocoön's fate. Illustration for Asger Jorn's article "Apollo and Dionysus" as published in Byggmästarn (Sweden), 1947

20 Graphic image of the movement of a pendulum. Illustration for Asger Jorn's article "Living Ornament" as published in <u>Forum</u> (The Netherlands), 1949

The tremendously consistent purge of empty ornamental elements of form is in reality classicism's Pyrrhic victory. It is a *tabula rasa* for what is to come; for an art of the future. —Asger Jorn

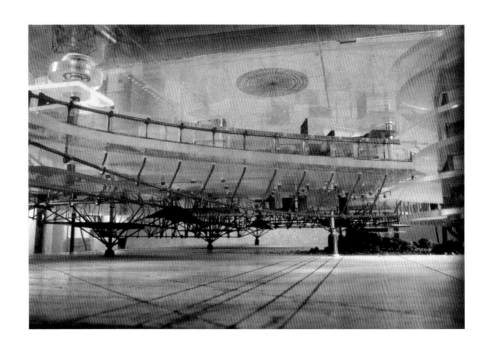

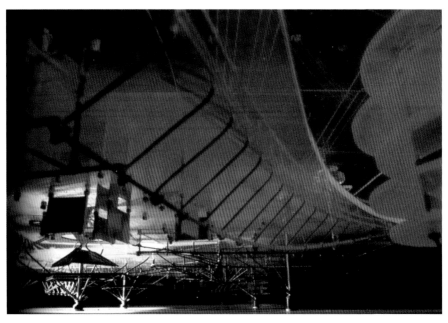

21 Constant, views of <u>New Babylon Yellow Sector</u>, 1958–61

22 Constant, Combination of Sectors, 1958–61

For many a year the gypsies who stopped a while in the little
Piedmontese town of Alba were in the habit of camping beneath the
roof that, once a week, on Saturday, housed the livestock market....
It's there that in December 1956 I went to see them in the company of
the painter Pinot Gallizio, the owner of this uneven, muddy, desolate
terrain, who'd given it to them.... That was the day I conceived the
scheme for a permanent encampment for the gypsies of Alba and that
project is the origin of the series of maquettes of New Babylon. Of a
New Babylon where, under one roof, with the aid of movable elements,
a shared residence is built; a temporary, constantly remodeled living
area; a camp for nomads on a planetary scale. —Constant

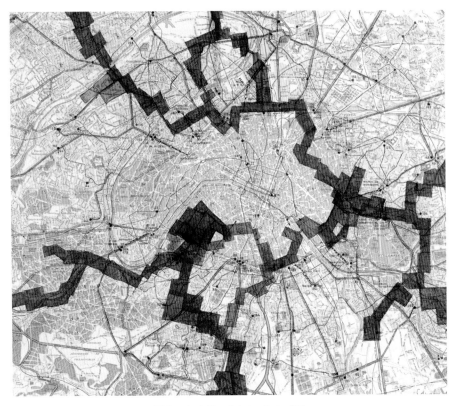

23 Constant, New Babylon Paris, 1963

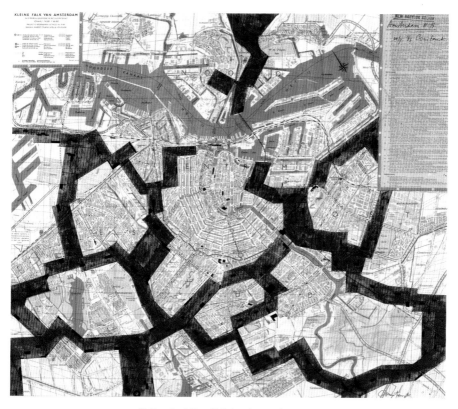

24 Constant, New Babylon Amsterdam, 1963

The first step, architecturally, would obviously be to replace the current pavilions with an autonomous series of small Situationist architectural complexes. Among these new architectures ... ought to be built perpetually changing labyrinths.... Should Les Halles of Paris survive until such a time as these problems will be posed by everyone, it will be fitting to try to turn them into a theme park for the ludic education of the workers. —Abdelhafid Khatib

25 Guy Debord, film stills from <u>In Girum Imus Nocte et Consumimur Igni</u>, 1978, incorporating Debord's <u>Game of War</u> and détourned images from war movies

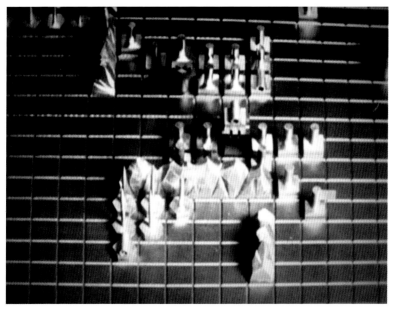

I have long striven to maintain an obscure and elusive existence, and this has enabled me to further develop my strategical experiments, which had already begun so well. As someone not without abilities once put it, this is a field in which no one can ever become expert. The results of these investigations—and this is the only good news in the present communication—will not be presented in cinematic form.
—Guy Debord

26 Guy Debord, film still from <u>Critique of Separation</u>, 1961,
showing Debord with Caroline Rittener

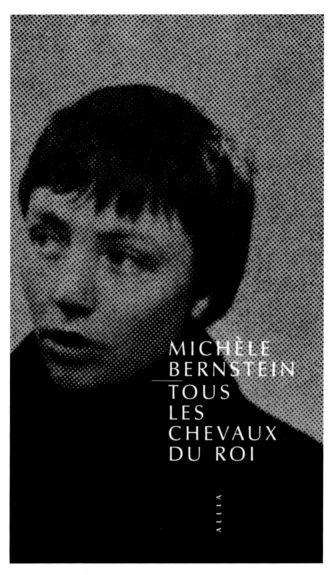

MICHÈLE
BERNSTEIN
—
TOUS
LES
CHEVAUX
DU ROI

ALLIA

27 Michèle Bernstein on the cover of the 2004 reissue
of her 1960 novel <u>Tous les chevaux du roi</u>

Hélène was at the center of a group that came apart. Her presence gave
it equilibrium, but later she became as useless as a grand staircase in
a ruined castle. Hélène didn't change, but a change in perspective had
abolished her function. We stopped seeing her for all these reasons,
and for no reason ... out of sadness. Not having anything to confront her
with, I refused to confront her, and there was a bad
fight on the telephone. —Michèle Bernstein

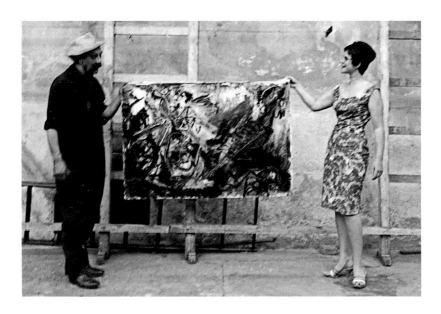

28 Jacqueline de Jong with Pinot (Giuseppe) Gallizio in Alba, 1960. Photographer unknown

29 Jacqueline de Jong with Asger Jorn at an opening of an exhibition of collages by Jacques Prévert, 1962. Photographer unknown

30 Jacqueline de Jong in her Paris studio. Photographer unknown

In 1962, the outrage expressed by de Jong that such a group could be so undemocratic as to seek to eject a 'majority' of its own members, could well be indicative that as an organization of affinities the Situationist International was self-selecting. The trumpeted exclusions are also indicative of its bid for "sovereign power"—a political act that announces its own state of exception, its own rules ("creating the sphere of its own reference"), and in so doing disregards any notion of a binding 'contract' being at the origin of its power. —Howard Slater

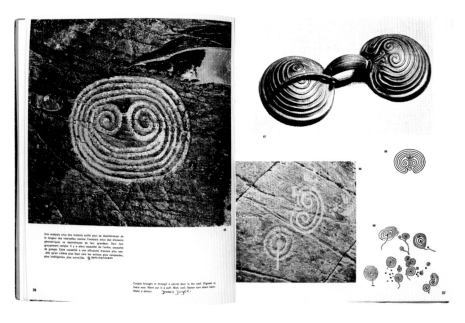

31 The Situationist Times 4, October 1963. Issue on the labyrinth

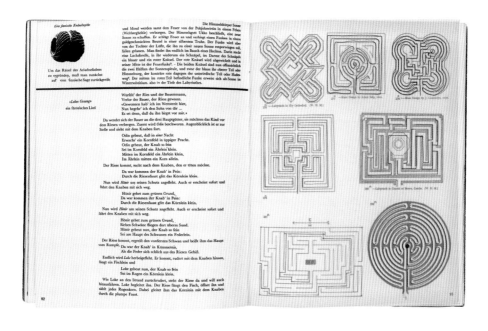

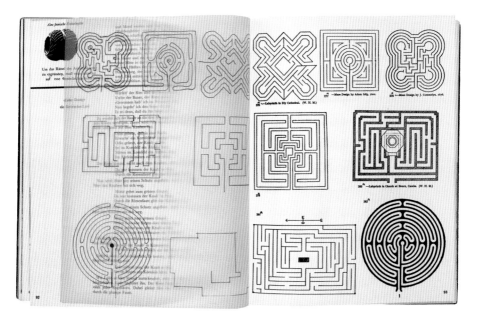

Samizdat movements, being utopian, seek to intervene in all areas of life. However, the anti-professionalism of samizdat biases it in favor of cultural and political activities and away from serious scientific investigation. Since Western society encourages specialization, once any given samizdat movement loses its dynamism it tends to be pushed into a single area of contestation. —Stewart Home

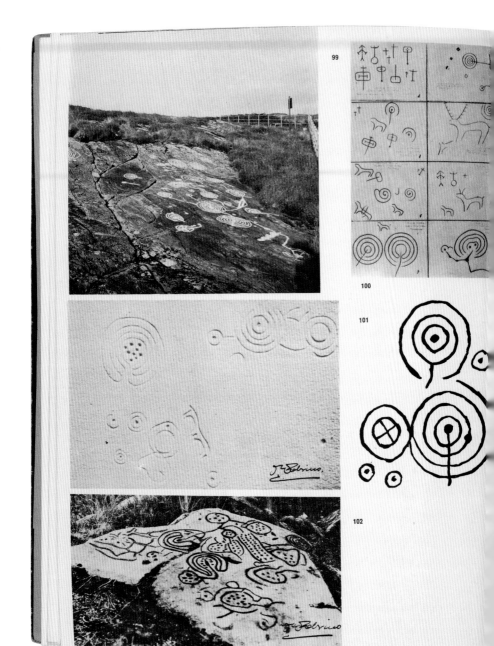

100

101

102

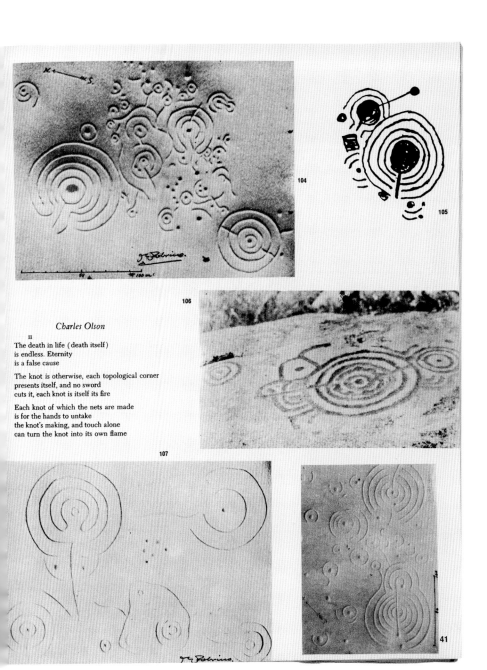

Charles Olson

II

The death in life (death itself)
is endless. Eternity
is a false cause

The knot is otherwise, each topological corner
presents itself, and no sword
cuts it, each knot is itself its fire

Each knot of which the nets are made
is for the hands to untake
the knot's making, and touch alone
can turn the knot into its own flame

31 The Situationist Times 4, October 1963. Issue on the labyrinth

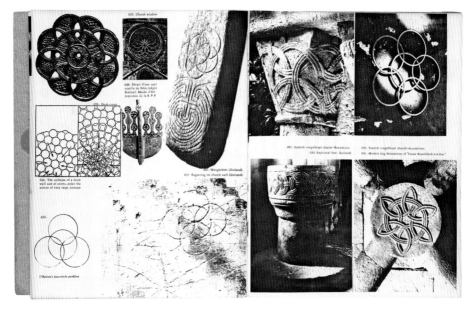

32 The Situationist Times 5, December 1964. Issue on the ring

In this number of The Situationist Times, we try to open up the problem of the ring, interlaced rings, and consequently chains ... we do not want to make any statement ... either in a so-called "symbolistic" way or in a scientific one, even though some of the contributors might show a certain tendency in one way or another. —Jacqueline de Jong

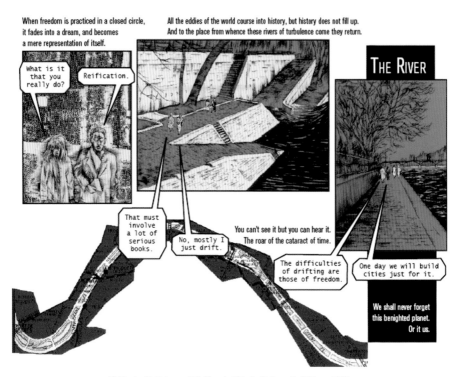

33 Kevin C. Pyle and McKenzie Wark, Cataract of Time, 2007.
From Totality for Kids, on-line work in progress

Guy came in, dressed in black from head to foot, and in black
corduroy no less! ... Flourishes of rare precision and without any
hurry. The real adventure novel is Céline. I'm entirely in agreement
with you there, Guy. He sat down with no preamble other than
his smile ... and ordered two liters of white wine, dry white wine.
—Patrick Straram